Painting the Head in Oil

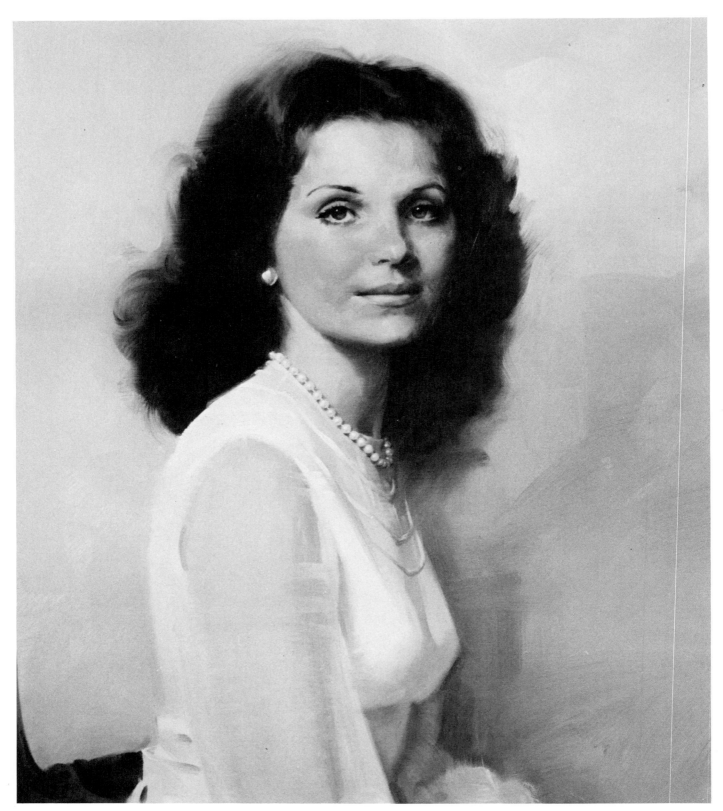

Mrs. Erol Beker. *This is a detail of the full portrait shown in color on page 129.*

Painting the Head in Oil

By John Howard Sanden

Edited by Joe Singer

WATSON-GUPTILL PUBLICATIONS, NEW YORK

PITMAN PUBLISHING, LONDON

Copyright © 1976 by Watson-Guptill Publications

First published 1976 in the United States and Canada by Watson-Guptill Publications,
a division of Billboard Publications, Inc.,
1515 Broadway, New York, N.Y. 10036

Published in Great Britain by Pitman Publishing, Ltd.,
39 Parker Street, London WC2B 5PB
ISBN 0-273-00282-1

Library of Congress Cataloging in Publication Data
Sanden, John Howard,
 Painting the head in oil.
 Bibliography: p.
 Includes index.
 1. Portrait painting—Technique. 2. Head in
art. I. Title.
ND1302.S26 1976 751.4'5 75-40175
ISBN 0-8230-3640-5

Manufactured in U.S.A.

First Printing, 1976
Second Printing, 1976
Third Printing, 1977
Fourth Printing, 1979

To Elizabeth, a lovely, inspiring lady

Contents

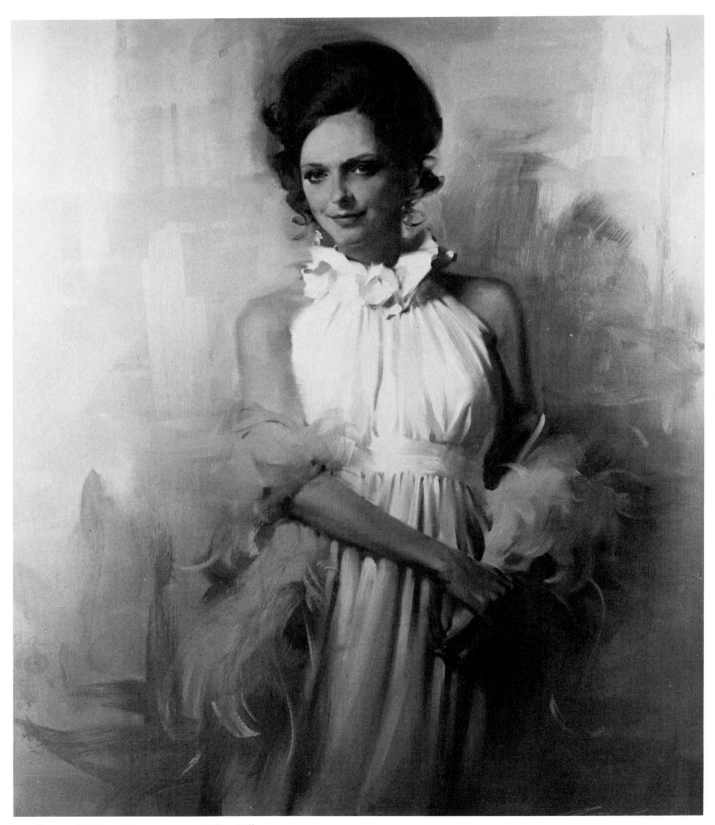

Sunny Griffin. *Oil on canvas, 42" x 35".*

Foreword

I cannot think of anything more difficult, or more fascinating, than attempting to paint an informative impression of a human being, in oils, in one sitting. To accomplish this singular and exacting task requires a considerable amount of energy, intelligence, perception, basic knowledge, sensitivity, and nerve.

There are very few who can really do it with distinction. But an ever-increasing army are taking up the attempt, as witness the swelling classes in art schools across the country. There are many possible subjects; still life, landscape, imaginative material, even abstraction—they are all challenging in their way. But the Everest of painting will always be—and has always been—the human face. It presents the double problem of rendering the exterior and capturing the personality. Nothing requires more of the painter—more audacity and skill—than to take his position before the blank canvas, with his sitter before him. As his brush touches the canvas, the painter is face-to-face with the ultimate challenge. This is the "big league" of painting.

The purpose of this book is to recommend a procedure which is called *alla prima* or *premier coup* painting. The idea is one of striking at once for an immediate impression, of going directly for a final effect. This is one of the great historic traditions of painting. It is squarely within the framework of impressionism.

This book is a discussion of my painting methods, rather than a how-to do-it manual. It's based on a series of lectures I give every fall at the Art Students League in New York City, and on the methods taught in my studio classes at the League.

My classes are a continuation of those conducted by Samuel Edmund Oppenheim, one of the great teachers of painting in America. His classes, conducted for many years in his private studio in New York and at the League, were always filled to capacity. His manner was courtly, gracious, and gentlemanly, but he was a strong, purposeful, and resolute teacher. He taught us the art of seeing—of *perceptive observation*. "The model is the teacher in this class," he always said. "She says nothing, but she tells you everything." Oppenheim had no patience with esthetics or idle theory. His approach to painting was uncomplicated and direct.

My principal goals in painting are, to sum them up in two words: truthfulness and directness. As far as content is concerned, everything is based on observation. As far as method is concerned, it is *premier coup*: direct, calculated, and purposeful. You'll find very little of esthetics or

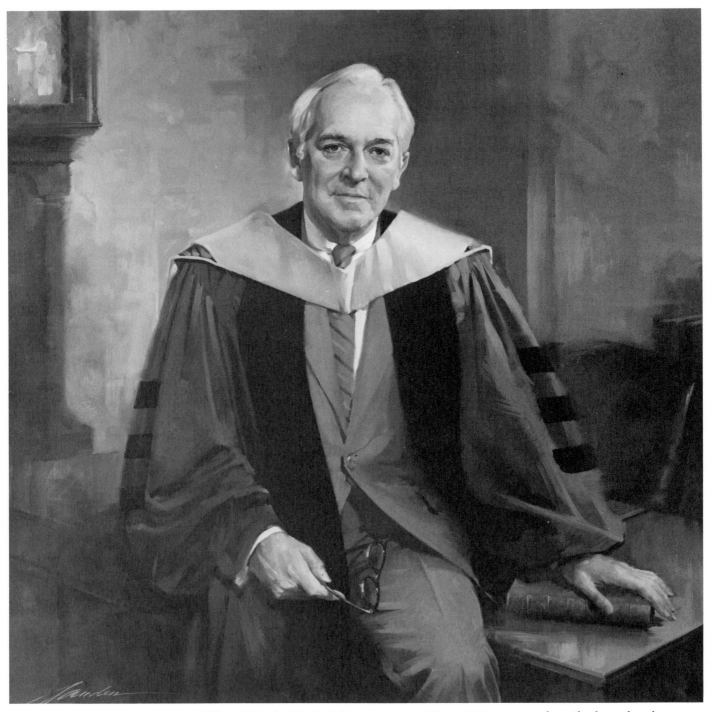

Dr. William Schuyler Pettit. *Oil on canvas, 44½″ x 42″. Here we see how the formal and informal approaches may be skillfully combined in a single painting. Although the model is dressed in the impressive robes of academe, he manages to impart a note of informality by perching rather jauntily on the edge of his desk.*

philosophy. I'm writing about something—the art of painting—which seems to me to be mainly an athletic undertaking, involving physical coordination between eye and hand. I've tried to be specific and unambiguous.

I've said that there is nothing more difficult or demanding than painting. It calls for a state of physical and mental alertness sustained throughout the session. There is no place for sluggishness. Every nerve must tingle. Every sense must be vibrating and sharp. Observe, analyze, respond with paint, all at white-hot speed. This is the painting act.

This is *not* a book on portraiture. It is a book on *painting* in which the subject matter just happens to be people. The real subject, after all, is *light*. What we are really observing and painting is *the effect of light* as it falls across forms. This is why I consider myself an impressionist.

I hope you'll enjoy this book, and more important, I hope you'll enjoy the kind of painting it describes. For all his sober dedication, Mr. Oppenheim loved to say to us, "Don't be so serious about it!" Meaning, I suppose, that, after all is said and done, painting must be basically a joyous act. Let the brushstrokes flow, he was saying. Let the colors sing.

John Howard Sanden

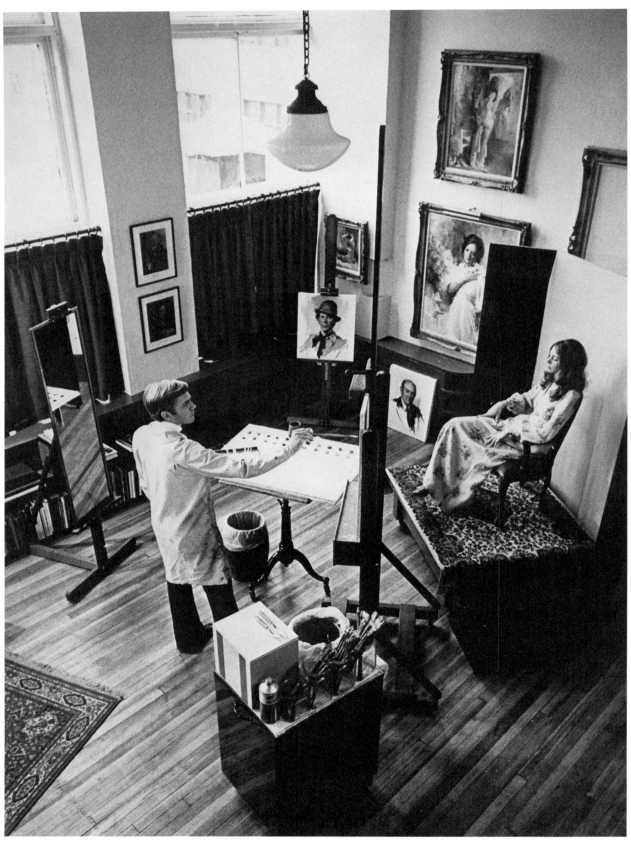

This photograph of my studio shows the entire arrangement for painting. A mirror just over my left shoulder permits the model (my wife) to watch the progress of the painting. The palette rests on an ancient cast-iron drawing-table base.

1. Materials, Equipment, and Furnishings

BRUSHES Because my painting method dictates that the brush be as clean as possible for every stroke, I advise having no fewer than 64 brushes on hand so that excessive time won't be spent cleaning and wiping brushes already soiled and that a fresh brush will be always available.

Since I also advocate placing a quantity of paint on the canvas and letting it stay there rather than blending, scumbling, or otherwise sloshing it about, it's absolutely vital that the artist be able to select the right brush for the particular passage he happens to be painting. The width of the brush must fit the area to be covered as closely as possible, and the only way this can be managed is for the artist to be free to reach for the right brush without a moment's hesitation once he has determined the hue, value, intensity, and placement of the anticipated brushstroke.

Therefore: (1) Collect as many brushes from the list which follows as you can afford. (2) Get to know each of them so well that you can reach for the right brush as the right time as instinctively as you reach for your toothbrush in the morning. Incidentally, brushes—even though they may be the same size and belong in the same category—tend to develop their own individuality so that they differ in character from their identical twins.

As your brushes grow old, frazzled, skimpy, or otherwise useless, discard them without a moment's hesitation and replace them with nice, fresh new ones.

I use five kinds of brushes in the following order of frequency:

Bristle Filberts. The overwhelming majority of my work is done with the bristle filbert, which is not—as one may suppose—a nut, but a kind of compromise between a flat and round brush, being somewhat long and flat but ending in rounded corners. I find this shape particularly useful in that it gives me control over the stroke: it doesn't produce the sharp edge imposed by a flat brush, nor does it feather, and it allows me to vary the width of the brushstroke. I also find it very easy to make a knife-edge stroke with a filbert if I so desire. All in all, it's my main all-around painting tool.

Bristle Broads. I use these valuable brushes in the big, broad sizes mainly for background effects, for the occasional blending I might do, or to simplify a passage that has been overpainted by dipping the brush into turpentine and stroking it over the area.

Bristle Fan Blenders. This is a brush that resembles a peacock's tail in full

courting display. I use it sparingly to drag a quantity of paint into an adjoining area without disturbing the strokes to any great extent. It can also be used to directly paint such smooth, flowing objects as hair, fur, or other soft materials. Due to the rather weak, indistinct quality of its hair, the fan blender must be used very sparingly lest it render a passage too superficial and pretty.

Sable Flats. I use these brushes to paint occasional fine details that might be difficult to achieve with the other brushes.

Sable Rounds. The Number 7 sable round is used to put the highlight (also called the catchlight) in the eye, and either this or the Number 12 flat is used occasionally to blend small passages in the face.

Here is the complete list of the brushes I recommend: Robert Simmons Series 42 "Signet" Bristle Filberts, Nos. 12, 9, 7, 6, 4, and 2 (six of each); Robert Simmons Series 40 "Signet" Bristle Broads, No. 8 (four); Robert Simmons Series 48 Bristle Fan Blenders, Nos. 6 and 3 (four of each); Robert Simmons Series 68L Sable Long Flats, Nos. 6, 4, and 2 (four of each); Robert Simmons Series 61R Red Sable Rounds, Nos. 12 and 7 (two of each).

This assortment comes to 64 brushes in all, and although it's sizeable, I've found it the absolute minimum necessary for a flowing, uninterrupted, productive painting procedure.

Unless sufficient brushes are available one begins to paint with brushes that aren't clean (you can wipe a used brush only so many times) and this leads to potential trouble since every new stroke now becomes tainted by previous mixtures and one ends up painting from memory rather than from direct observation.

BRUSH CLEANER Even with the full allotment of brushes at your disposal, after you've painted for a period of time—let's say a couple of hours—it comes time to stop and clean house. This serves both to restore your painting materials and to revive your flagging energies and spirit.

Begin by washing all the brushes you've used—by now perhaps the entire complement—in a brush cleaner that you can fashion yourself.

I use a laundry pail which I line with heavy plastic and into which I then fit an ordinary metal kitchen strainer. I fill this pail with turpentine so that it covers the strainer, I then take each of the soiled brushes and scrape them over the strainer so that the discarded paint drops through to the bottom of the pail. I wipe the brush with paper towels as it comes out, leaving it almost as clean as it was before the painting session commenced. By the time I've cleaned and dried all the brushes, I've regained much of my enthusiasm and am anxious to begin painting anew. I also use this rest period to clean the areas on my palette where I've mixed my color combinations, so that everything—mind, body, spirit, brushes, and palette—are ready for a fresh assault on the canvas.

I also use the brush cleaner at the end of the day's painting to scrape off my brushes before washing them with soap and water.

When the residue of paint under the strainer grows too high, I take out the strainer and remove the plastic liner containing this residue. The residue-filled liner is discarded, leaving the pail itself clean. I then reline the pail with fresh plastic, replace the strainer, add new turpentine, and am ready to begin all over again.

PAINTING KNIVES

I own two painting knives that I use for two separate functions, neither of which is painting: I use the bigger knife to scrape my palette clean and the smaller to mix paint when I prepare my own premixed tints which I then put up in tubes.

Although the knife is an acceptable and traditional tool for applying paint, I employ it very, very rarely in an occasional, stray passage.

CANVAS AND CANVAS BOARDS

I use linen canvas for all my serious painting and cotton canvas and canvas boards for preliminary studies or demonstrations. However, I strongly urge students to make use of cotton canvas and canvas boards for two good reasons: (1) Cotton is cheaper than linen. (2) Because it's cheaper it tends to free a learning artist's inhibitions so that he doesn't feel compelled to follow through to the bitter end even if he has made a false start (as he would on the more expensive linen); it encourages him to keep starting over until he gets what he's after. This leads to looser, less finicky painting and to a more self-critical attitude toward one's work.

Linen Canvas. My preference is for U.S. Art Canvas No. 9L, which comes in 90″ x 6 yard rolls and is single-primed. I prefer this particular canvas because of its light tone and its texture, which is somewhat rougher than the double-primed; I recommend it for all important painting.

MEDIUMS AND VARNISHES

Painting Medium. The only painting medium I use is Taubes Copal Painting Medium, light. I use it sparingly, only on those occasions when I want my paint to flow more easily. However, I find myself using it less and less often and relying more on the paint just as it comes from the tube. The reason I turned to Frederic Taubes' concoction is that I read his arguments regarding the value of hard resins in the formulation of painting media and found them valid.

Retouch Varnish. To bring up a passage that has gone dry between painting sessions a retouch varnish is sprayed or blown onto the area. I use two kinds of retouch varnish: one requires an atomizer and lungs, the other comes in an aerosol can. The chief difference between the two is that the former dries faster than the latter. For the atomizer I use Weber Sphinx retouch varnish; in the spray can type I use Winsor & Newton retouch varnish.

Damar Varnish. Since the bulk of my work is commissioned portraiture, which leaves my possession the moment it's concluded, I spray the completed work with retouch varnish before releasing it. For the final varnishing, which most experts recommend to be performed a year after the painting has dried, I suggest damar varnish in the bottle.

Turpentine. I use pure spirits of gum turpentine (available in any art or hardware store) for two purposes: (1) As a medium to thin the paint when laying in the background. The turpentine makes the paint dry matte, which in turn makes the background seem to recede. (2) To clean my brushes.

Oil of Cloves. Oil of cloves is the tradtional medium for retarding the drying time of oil paint. When I want to keep a passage of paint wet for a longer period so that I can paint "into the soup," as this is called, I use one drop of oil of cloves to a mound of paint. This keeps the paint juicy and wet for up to seven days. However I urge extreme caution regarding this

practice since too much of this liquid may keep the area wet for too long, and may—according to experts—harm the paint surface. Oil of cloves is available in most drugstores.

Chloroform. I use chloroform to loosen undesirable areas of paint and regain the original surface with no damage to the canvas or priming. You'll find the instructions and proper precautions regarding this potentially dangerous solution in Chapter 6. Chloroform is available in drugstores; however you must tell the pharmacist your reasons for buying the stuff lest he consider you a potential Jack the Ripper.

FURNISHINGS

Easels. The best studio easel is the ratchet type that tilts forward and backward, moves up and down easily, accepts large canvases, and is mounted on casters for instant mobility.

For the portable setup, the ideal is the so-called French easel, which folds up into a neat package and which when fully set up accommodates a canvas, a palette, and metal-lined drawers for your paints, brushes, and accessories.

Model Stand. For studio work I find a model stand an indispensable item. I built mine myself. It measures 48″ x 40″ and is 18″ high, which is exactly a fourth of my height. Thus, since I paint standing up, when the model is seated on a chair placed on this stand his eyes are just about parallel with mine.

I also constructed a short flight of steps so that the sitter can mount the stand safely and gracefully.

The stand is set on casters, so when it's not otherwise occupied it serves as an excellent work area for various tasks around the studio.

Chairs. A painter should accumulate all kinds of chairs and stools to accommodate various posing situations. The more you have the greater are your chances of achieving variety in your paintings. A loveseat, sofa, or couch will also come in extremely handy. Whenever you encounter some interesting piece of furniture try to add it to your studio collection.

Mirror. I keep a 45″ x 30″ mirror permanently mounted on an easel with casters. It serves several functions: (1) It allows me to see my painting in reversed image, which makes more obvious any faults in symmetry I might have overlooked when looking at the painting or subject directly. (2) It can be set up in such a way that the sitter can follow the progress of the painting in the mirror and thus alleviate the monotony of posing. (3) It provides the artist a more sweeping view of the painting since it automatically doubles the distance from viewer to canvas or subject.

Reducing Glass. This handy little tool considerably reduces the view of the model and painting without any accompanying distortion and thus allows the artist to check for any possible compositional errors.

Calipers. Calipers are a simple measuring device commonly employed by sculptors to measure the dimensions of people and objects. Some painters who are after precise proportions use them to measure a sitter's head or individual features then transfer these readings to the canvas.

Background Screen. This is a most useful accessory around the studio with which to create instant backgrounds through the use of various toned cloths or papers selected to fulfill an appropriate need.

My screen is composed of five hinged panels, each 82″ high and 13″ wide. It's set on casters so that it can be moved into place or rolled away quickly and easily.

I use various draperies and pastel papers in many tints and shades that I affix to this screen as required.

MISCELLANEOUS EQUIPMENT

Other items I find handy around the studio include:

1. Heavyweight stretchers of various sizes.

2. A staple gun and staples for tacking the canvas to stretchers.

3. Canvas pliers to keep the canvas taut as it's being tacked and to crimp the tubes of paint after preparing my own mixtures.

4. A roll of paper towels on a rack for wiping the brushes between strokes and for other cleanup jobs.

5. A box of stacked napkins for the same purpose.

6. Eye droppers for the oil of cloves.

7. Cups and jars to hold the painting medium and other solutions.

8. Empty tubes for my premixed tints.

9. A special hinged 12″ x 12″ glass mixing palette which I will describe in detail in Chapter 2.

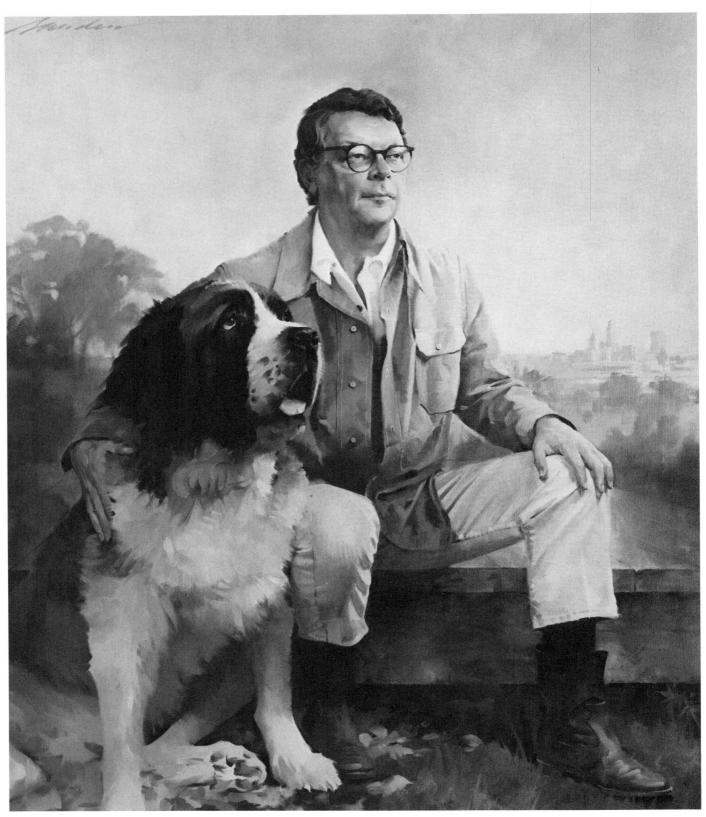

Mr. Earl T. Barnes. *Oil on canvas, 48" x 40." The St. Bernard was very old and feeble when this was painted, but greatly beloved by the family, so we decided to give him prominence in the painting. Mr. Barnes is active in the civic life of Cincinnati and I included a skyline of the city even though you could not really see it from the Barnes' lovely suburban home. (Collection Mr. and Mrs. Earl T. Barnes)*

2. The Palette of Colors

I use an assortment that combines manufactured colors and a number of tints that I premix and put up in tubes myself. I recommend to my students and to all who hope to gain practical advice from this book that they do the same. This process of mixing and tubing is much simpler than one might at first suppose, particularly with the exact measurements and devices I will provide. But first, the ready-made colors. Although many brands of manufactured oils are good, I have settled on Rembrandt oil colors, manufactured in Holland by the Talens company. For my sketches and demonstrations I use Permanent Pigments oil colors, and I recommend that you use these for mixing the special colors described on page 22.

WHITE The only white I use is Permalba, made by the F. Weber company of Philadelphia, which is very opaque and offers the smooth, buttery, easy-flowing texture and consistency I look for.

THE EARTH COLORS **Yellow Ochre.** Next to white, this is probably the color I use most in my portrait work. It's a dull, very opaque yellow and is included in all the light flesh areas and in most of the halftones.

Burnt Sienna. I use this brilliant, semitransparent reddish brown in mixtures in all my shadow areas. It's also very useful for highlights in darkish hair and for painting dark-skinned subjects.

Burnt Umber. This is my basic brown. It's dark, semiopaque, and one of the fastest driers among the oil colors. It's particularly handy for painting dark hair and skin. Mixed with alizarin crimson, it's ideal for the dark shadows at the corners of the eye and for nostrils.

Venetian Red. A rich, opaque red-brown with powerful tinting strength, it's useful in some of the ruddier light areas on the nose and cheeks, and almost always in the mouth and ears. While not absolutely essential, its convenience makes it a worthy addition to the palette.

This completes the group of earth colors on my palette. Before going on to the cadmiums I want to mention one color that fits into no particular category but which belongs here, between the earths and the cadmiums: alizarin crimson.

ALIZARIN CRIMSON This is a rich, completely transparent, deep red that tends toward the cool, pinkish side of the red spectrum. Mixed with ultramarine blue it

creates beautiful purples and violets. I use it quite extensively for the pinker accents in the light areas, and mixed with burnt umber for the slash between the lips and for the corners of the mouth.

THE CADMIUMS My palette includes these three cadmiums:

Cadmium Red Light. This is an intense, opaque, warm red that's the clearest and brightest of all my reds. I use lots of it in every mixture within the light flesh areas and in most halftones. Actually, it's part of my basic flesh-tone mixture along with yellow ochre and cerulean blue. I also use it for mouths wearing lipstick.

Cadmium Orange. Another intense, opaque color with powerful tinting strength. It falls halfway between a yellow and a red. I use it to enliven shadow mixtures that have gone dead by throwing a warm reflected light into the dark areas.

Cadmium Yellow Light. An intense opaque yellow that's warm, clear, and brilliant. In other than flesh mixtures, it's my prime yellow. Mixed with white it turns a cool, lemon color and in combination with blue it produces interesting greens.

THE COOL COLORS I employ four colors in this category, two greens and two blues which serve all my requirements for the cool side of the palette.

Chromium Oxide Green. Very dull and opaque and of extremely powerful tinting strength, this color is particularly useful for cool reflected lights and cool halftones. Although it's a recent addition to my palette, I wouldn't do without it now.

Viridian. A bright and transparent green. I use it in combination with burnt sienna in almost every shadow mixture.

Cerulean Blue. Deep and opaque but rather weak in tinting strength, this is a most useful cool, clear blue that I use to gray down flesh tones in the light areas and for planes in the head I want to make recede.

Ultramarine Blue. A transparent blue that's useful in painting hair and, occasionally, the iris of the eye. I don't use it in flesh-tone mixtures.

IVORY BLACK Ivory black is rich, deep, and the slowest drier on my palette. I use black mainly for hair, the pupils of eyes, and mixed with white for blue irises. It's not used for flesh-tone mixtures but to subdue colors in all other color situations.

This completes the list of ready-made colors in my palette and brings us to the premixed flesh tints that I prepare from my own formulas.

MIXING YOUR OWN FLESH TINTS Years ago I discovered that in painting flesh I had to repeatedly prepare certain mixtures to achieve the results I was after. Subsequently I came to the realization that much time and effort could be saved if these tints were available in ready-made mixtures and I decided to do something about it. Accordingly, I worked out detailed formulas encompassing the ten such tints I required, and began to put them up in tubes for my own use and urged my students to do the same.

Incidentally, the ten premixed colors I am about to name are all concocted from the ready-made colors I have described, the only exception

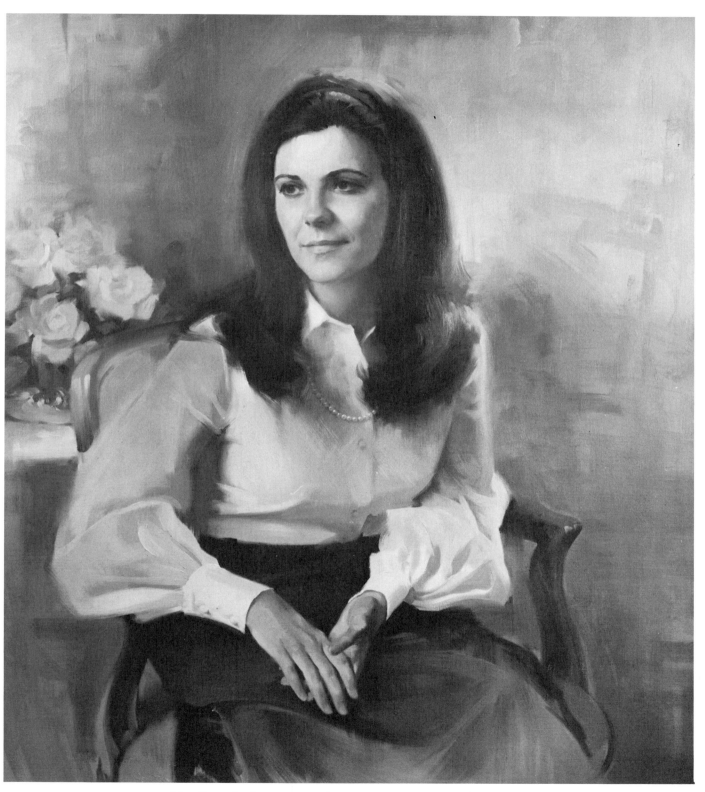

Mrs. Scott Parker Anger. *Oil on canvas, 36″ x 30.″ This lovely young lady assumed a graceful, natural pose without any coaching from me. The pose of her hands was particularly beautiful to paint. When Mrs. Anger arrived for her first sitting, she brought a dress that had been sewn especially for the occasion. But as we worked on the portrait, we both decided that a blouse-and-skirt combination would be more youthful and attractive, so Mrs. Anger borrowed a white blouse from my wife, and a dark brown skirt, and she wears them in the finished painting. (Collection Mr. and Mrs. Jack C. Schoo)*

being raw sienna, which is not one of the regular colors on my palette. They are listed by name and by their value number, which can be matched against the value chart shown on page 43.

Those who would prefer to prepare their own premixed colors can refer to pages 57 for specific instructions.

Here are the ten premixed tints:

Light I (Value 4). A mixture of white, yellow ochre, and cadmium red light, which is useful on those planes nearly at right angles to the main light source. A clear, clean mixture for the lightest lights.

Light 2 (Value 4). A mixture of white, yellow ochre, cadmium red light, and cerulean. This is somewhat darker, warmer, and grayer than Light 1 and is used primarily in the darker areas of the light flesh tone. It may be considered the basic flesh color for Caucasian skin.

Light 3 (Value 5). A mixture of white, yellow ochre, cadmium red light, and cerulean. A warm, pink color for ruddy flesh in the light areas. A touch darker than Light 2.

Halftone 1 (Value 5.). A mixture of white, yellow ochre, viridian, and cadmium red light. This is an essentially cool tint used chiefly for the receding planes in the head.

Halftone 2 (Value 6). A mixture of white, cadmium red light, yellow ochre, chromium oxide green, and cadmium orange. Darker and warmer than Halftone 1 and used in those areas falling at the junction of the light and dark areas of the head.

Dark 1 (Value 8). A mixture of burnt sienna, white, viridian, and cadmium orange used for general shadow in Caucasian skin and very useful for painting dark-skinned subjects.

Dark 2 (Value 9). A mixture of burnt sienna, viridian, and cadmium orange. A deeper tint than Dark 1.

In addition to these flesh tones, I have also prepared 3 neutral grays which I find very useful in reducing and neutralizing the intensity of the flesh colors and in painting passages of gray color. They are:

Neutral 3 (Value 3). A mixture of white, yellow ochre, and ivory black. A rather light, warm gray.

Neutral 5 (Value 5). A mixture of white, yellow ochre, and ivory black. A medium-toned gray used to neutralize the middle values.

Neutral 7 (Value 7). A mixture of white, ivory black, and raw sienna. A warm, dark gray used for neutralizing the dark colors.

These three lights, two halftones, two darks, and three neutrals make up my premixed assortment. They have freed me from the tyranny of having to stop frequently to mix new batches of color and have lent new verve and freedom to my painting. I hope they will do the same for you.

The one important thing to remember regarding these premixed tints is that they offer no instant formula for getting the flesh colors exactly so each time out. Nothing could be farther from the truth; despite the fact that they're *already* mixed, I rarely use these tints alone as they issue from the tube but usually in combination with one or more other colors

Mrs. Scott Parker Anger. *Oil on canvas, 36″ x 30.″ This lovely young lady assumed a graceful, natural pose without any coaching from me. The pose of her hands was particularly beautiful to paint. When Mrs. Anger arrived for her first sitting, she brought a dress that had been sewn especially for the occasion. But as we worked on the portrait, we both decided that a blouse-and-skirt combination would be more youthful and attractive, so Mrs. Anger borrowed a white blouse from my wife, and a dark brown skirt, and she wears them in the finished painting. (Collection Mr. and Mrs. Jack C. Schoo)*

being raw sienna, which is not one of the regular colors on my palette. They are listed by name and by their value number, which can be matched against the value chart shown on page 43.

Those who would prefer to prepare their own premixed colors can refer to pages 57 for specific instructions.

Here are the ten premixed tints:

Light I (Value 4). A mixture of white, yellow ochre, and cadmium red light, which is useful on those planes nearly at right angles to the main light source. A clear, clean mixture for the lightest lights.

Light 2 (Value 4). A mixture of white, yellow ochre, cadmium red light, and cerulean. This is somewhat darker, warmer, and grayer than Light 1 and is used primarily in the darker areas of the light flesh tone. It may be considered the basic flesh color for Caucasian skin.

Light 3 (Value 5). A mixture of white, yellow ochre, cadmium red light, and cerulean. A warm, pink color for ruddy flesh in the light areas. A touch darker than Light 2.

Halftone 1 (Value 5.). A mixture of white, yellow ochre, viridian, and cadmium red light. This is an essentially cool tint used chiefly for the receding planes in the head.

Halftone 2 (Value 6). A mixture of white, cadmium red light, yellow ochre, chromium oxide green, and cadmium orange. Darker and warmer than Halftone 1 and used in those areas falling at the junction of the light and dark areas of the head.

Dark 1 (Value 8). A mixture of burnt sienna, white, viridian, and cadmium orange used for general shadow in Caucasian skin and very useful for painting dark-skinned subjects.

Dark 2 (Value 9). A mixture of burnt sienna, viridian, and cadmium orange. A deeper tint than Dark 1.

In addition to these flesh tones, I have also prepared 3 neutral grays which I find very useful in reducing and neutralizing the intensity of the flesh colors and in painting passages of gray color. They are:

Neutral 3 (Value 3). A mixture of white, yellow ochre, and ivory black. A rather light, warm gray.

Neutral 5 (Value 5). A mixture of white, yellow ochre, and ivory black. A medium-toned gray used to neutralize the middle values.

Neutral 7 (Value 7). A mixture of white, ivory black, and raw sienna. A warm, dark gray used for neutralizing the dark colors.

These three lights, two halftones, two darks, and three neutrals make up my premixed assortment. They have freed me from the tyranny of having to stop frequently to mix new batches of color and have lent new verve and freedom to my painting. I hope they will do the same for you.

The one important thing to remember regarding these premixed tints is that they offer no instant formula for getting the flesh colors exactly so each time out. Nothing could be farther from the truth; despite the fact that they're *already* mixed, I rarely use these tints alone as they issue from the tube but usually in combination with one or more other colors

to suit the demands of *each* particular situation. They are never to be thought of as mechanical aids for automatic, preordained flesh-tone painting but merely as valuable time-savers.

A RESTRICTED VS. AN EXTENSIVE PALETTE

My assortment of standard and premixed tints comes to 24 in all. I find this number just right for my purposes. More would only increase the number of color combinations I would have to master; fewer wouldn't do since I would miss certain colors that I now find indispensable. I don't know whether the assortment I work with now should be considered limited or extensive. It's just big enough to provide the mixtures I need except for the possible exception of some unusual fabric that might require a specific tube color.

However if I were pinned down and *forced* to eliminate, I might make do with only one green and leave out the chromium green oxide, possibly leave out Venetian red and make do with burnt sienna, possibly leave out cadmium orange and mix it from cadmium red light and cadmium yellow light, and leave out cerulean, keeping ultramarine as my only blue.

But what's the point of a limited palette if it merely hampers one's efforts? Would a carpenter confine himself to one hammer if two helped him do the job better and more easily?

Colors, like brushes, are an artist's tools and there's no earthly reason why he shouldn't take advantage of every *useful* one. On the other hand, painting with forty colors would be just as detrimental as painting with too few since it would render the process complex and unwieldly.

The right palette of colors is one extensive enough to supply all possible combinations without throwing you into a state of utter confusion.

THE PALETTE

My studio palette is a plate of clear glass ¼″ thick and 27″ x 36″ in diameter. I lay this glass over a piece of white cardboard and tape the edges together to keep the paint from running down onto the cardboard.

I need a palette this size to have sufficient space to accommodate a constant flow of fresh decisions during the painting session. Since my method is to mix just enough paint at one time for a single brushstroke, this results in many mixtures; so a big mixing area is in order.

I use a clear glass for my palette for several reasons: (1) By slipping the board underneath I can mix my paints against a white background, and since I paint on untoned canvas I can estimate accurately how the mixture will appear on the white surface. (2) If the board underneath should become sullied for some reason, I can always replace it with a new one. (3) Glass is easy to scrape and wipe clean, and since I discard all my paint at the end of the day and squeeze out all new paint the next time out, this is a big consideration.

The palette rests on an old cast-iron drawing table that's set on casters. It's exactly 39″ high, which is just right for me in my customary standing painting position.

When I'm painting, the palette is always kept on the same side as the model. I try to see to it that the light hitting the model and the palette is approximately of the same value and intensity.

Setting the Palette. I lay out my colors on my palette in generous blobs at least 2″ in diameter.

Note that there are three batches of white. Since white is the most frequently used color in painting, I make sure to have enough clean white to

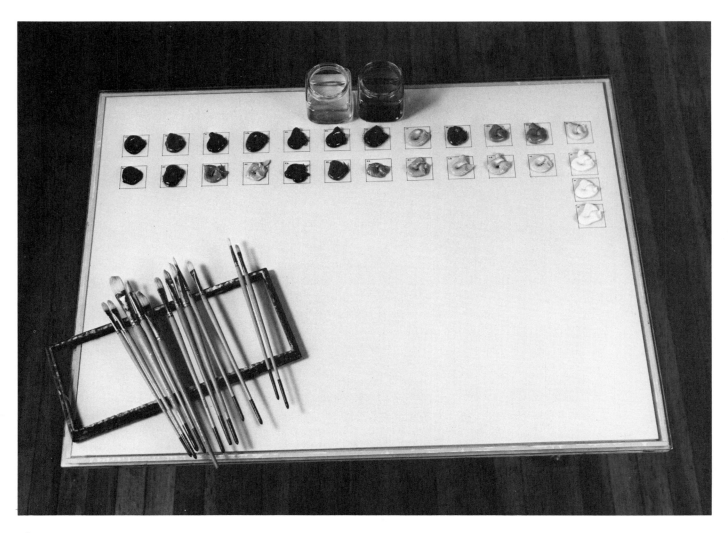

Standard Colors:

Ultramarine Blue Deep	Cerulean Blue	Viridian	Chromium Oxide Green	Alizarin Crimson	Burnt Umber	Burnt Sienna	Cadmium Orange	Venetian Red	Cadmium Red Light	Yellow Ochre	Cadmium Yellow Light

Pro Mix Colors:

Ivory Black	Neutral 7	Neutral 5	Neutral 3	Dark 2	Dark 1	Halftone 2	Halftone 1	Light 3	Light 2	Light 1	Permalba White

Permalba White

Permalba White

An overhead shot of my painting palette is seen at top. It's a piece of glass 27" x 36" in diameter, ¼" thick, with a white sheet of cardboard underneath and mounted on a cast-iron stand. The arrangement of colors is shown in diagram above. I break the mixing area up into three sections: lights on the right side of the palette, halftones in the middle, darks on the left, and all other mixtures on the farthest left of the palette.

carry me through the session.

As you can see, the arrangement of the standard colors runs, from the right to the left of the palette as it faces me, from white to the earths to the cadmiums to the cools. This is because I find myself using white, yellow ochre, burnt sienna, and burnt umber most often in mixtures, and it's better for me to have these colors closest to my painting.

The premixed tints are laid out with the lights, halftones, shadows, and neutrals, again running from (the palette's) right to left.

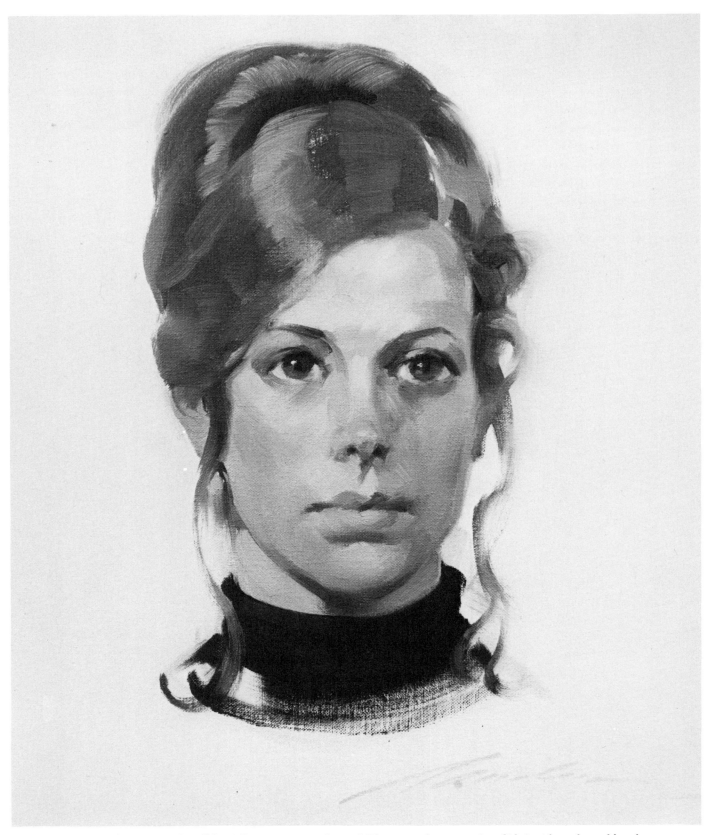

Candida. Oil on canvas, 18" x 14." The areas between Candida's sidecurls and her face can be considered negative shapes. By appraising and setting them down correctly, I was able to obtain an accurate portrayal of her other proportions, which constitute the positive shapes of her head.

3. Drawing the Head

Unlike many other painters, I don't differentiate between drawing and painting. To me, these are both part of the same process; each time I place a brushstroke I am in fact painting *and* drawing. The preliminary marks that I use to begin a painting of the head can be likened to a map rather than a full-scale drawing. I advise against the latter in preparing a portrait because not only will it be quickly obliterated anyway, but it's too confining. A full-scale preliminary drawing involves a commitment, and you should be free to change the painting as it progresses.

To my way of thinking, once the artist divides drawing and painting into two disparate functions he's heading for trouble, since after completing the drawing aspect of the portrait he may be tempted to forget that aspect and concentrate only on getting the value, hue, and intensity, forgetting position—which is the *most important* of the four elements, guiding every stroke you place on the canvas! You can paint a head in which the position of the strokes is absolutely right even though the values and colors are somewhat off and still come up with a passable portrait, but sacrifice position and you're doomed to failure.

Position *means* drawing, and each time you place a brushstroke you're in fact not painting but modeling the form, or if you like—drawing. To some, drawing represents working in line as opposed to painting, which (to them) means working in value and color. To this I say—bunk! Drawing is position, placement, modeling—all factors that are present each time brush is applied to canvas. The only time pure line is employed in my method is in the very first strokes I quickly lay in to guide my subsequent steps.

I cannot stress the above too often or loudly enough. It's so vital to the complete understanding of the method I teach that it may well be the most important thing I have to say in the book.

A final observation. Painting with the brush is actually the most sophisticated kind of drawing since you're simultaneously turning the planes of the face, making objects seem to recede or advance, and getting the dimensions just so. It's impossible to place a brushstroke of paint on the canvas without being involved in a drawing decision.

A SECRET DEVICE Now having said all this and having aired my views on the subject, I'm going to let you in on a little secret that's absolutely guaranteed to improve your drawing both for drawing's sake and for painting.

This secret consists of a device once widely used by all artists and art students but now fallen into disrepute. At one time it was an absolute

requirement in all art schools but now I seldom see it. I used to insist on its use in all my classes when I taught in the Midwest. Miraculously, it's still available in art material stores for a nominal sum and if you use it properly and conscientiously it will work absolute miracles with your drawing whether with pencil or brush. In fact, it's the *only* thing that will. However, the thing to remember is that once acquired, the device must be used in every available spare moment and in every situation possible—on trains, in cars, at home—everywhere.

This secret device, my friends, is a sketchbook. For the only way to learn to draw is by drawing.

THE FOUR PRINCIPLES OF DRAWING There are no shortcuts, mysterious schemes, involved diagrams, complex anatomy charts, or secret formulas to achieve good drawing. The main ingredients are observation and selection. Or to put it simply: the ability to see, to reduce the great sum of information ingested by the eye from a very complicated to a very simplified form—and finally, to put it all down on paper or canvas.

However in order to give some formal substance to these two processes of observation and reduction or selection, I've worked out four factors to consider when contemplating the position of a brushful of paint onto the surface, i.e., drawing. They are: *angles, mapping and proportion* (or relative distances), *plumbing,* and *positive and negative shapes.*

Let's consider these four factors in sequence:

Angles. To draw in angles means that—rather than slavishly following the contours of a head of hair, for example, with its dozens of possible dips and knolls—you reduce the entire mass to two or three straight angles that will follow the *general* direction of the hair. Thus, through this radical simplification you end up with no more than three or four horizontal, vertical, or diagonal planes that may represent twenty, thirty, or more short, straight, angular, or curved lines.

This process of reduction allows you to master and control a potentially bewildering array of conflicting and confusing minor details that might otherwise drive you to absolute distraction in trying to capture every tiny dip, bump, and hollow. Once you learn to *see in angles*, the complicated mass before you will assume such obvious, dominant, significant angles that every brushstroke you lay from then on will follow a *definite* direction. See the demonstration relative to this on page 34.

Mapping and Proportions, or Relative Distances. When considering the proportions of the subject before you (since we're talking about the head I'll stick to the features thereof), it's vital to establish a kind of map which will indicate the relative distances and relationships between points of importance on this form, and having noted these points, to mark them accordingly.

This process is one in which all esthetic considerations are put aside for the sake of sheer *accuracy*. In other words, where does the corner of the left eye lie in relationship to the edge of the nostril, or the corner of the mouth, or the Adam's apple, etc.

If enough such landmarks are simply but accurately stated throughout the painting, every feature and plane on the picture *must* emerge correct since it is right as to size and position in relation to all the other features in the portrait.

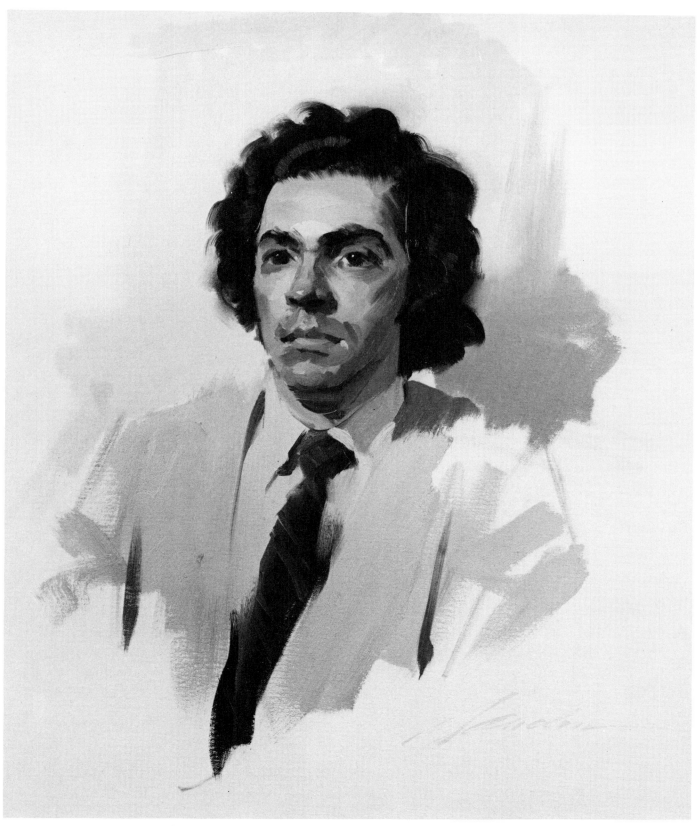

Ramon Mejia. *Oil on canvas, 30″ x 24.″ In drawing Ramon's head in the preliminary steps, I avoided marking all the dips and hollows created by his rather curly hair, expressing only its main thrusts and angles and leaving the smaller details for the final stages of the painting.*

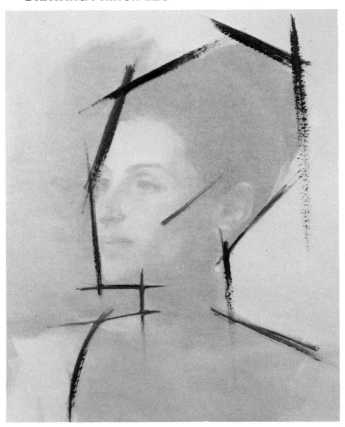 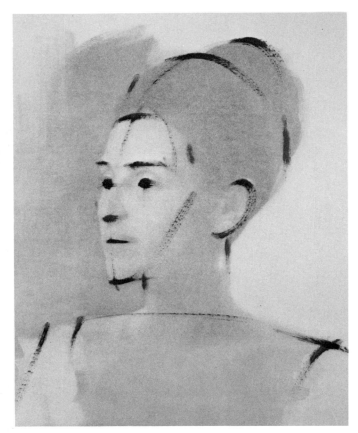

Angles. *Whenever you draw the head look for the angular direction taken by the planes, forms, and contours. Use your brush handle to check these angles, and draw them accordingly.*

Mapping and Proportions. *This is the aspect of drawing called mapping. It consists of establishing strategic points on the "map" and marking the relative distances between them.*

Plumb Lines. *Every point on the preliminary map is related to other points lying somewhere on imaginary plumb lines running vertically or horizontally across the form.*

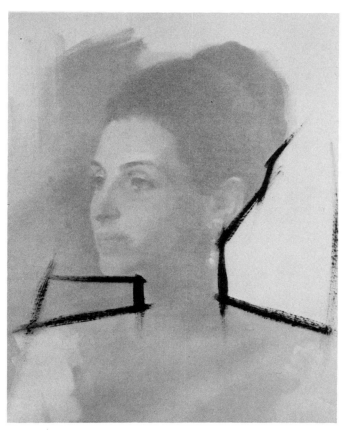

Negative and Positive Shapes. *By finding and setting down negative shapes correctly, you can obtain accurate positive shapes.*

Plumbing. A plumb line is simply a string tied to a weight which through the process of gravity creates an accurate vertical line when allowed to dangle freely. It is one of the finest means of establishing the landmarks we've just discussed since it reveals precisely what lies directly on a straight line with something else.

You can work with an actual plumb line, but I suggest the *mental* use of this device or at least the substitution of a brush handle, since holding a plumb line while painting seems somewhat clumsy and mechanical.

The plumb line can be used both vertically and horizontally, by extending such a straight line up and down or from side to side (using the brush handle until the eye becomes trained to do this automatically) and following it from end to end to observe which of the landmarks falls directly upon it.

Positive and Negative Shapes. A most excellent method of checking the accuracy of a drawing is through the use of positive and negative shapes. To consider what each of these is, visualize a sitter posing against a yellow screen. The model's head and shoulders are the positive shape; the areas of yellow all around the contours of his head, neck, and shoulders are the negative shape or shapes.

By reversing the usual order of seeing and *shifting your focus from the positive to the negative shape*, you can observe and put down this latter shape on the canvas (it's usually a much simpler shape) and be assured that the positive shape will then emerge in accurate contour and proportion.

A good example of this is the space running from between the point of the chin under the face to the neck, which, incidentally, most students paint too long because they concentrate their attention on the chin and neck and fail to note the *actual* length of the *negative* shape that exists there.

This method can also be applied to such areas as the space within the crook of an arm when it's leaned on a hip, or the space created by the frames of eyeglasses in a three-quarter profile.

Drawing the head can be a fairly simple procedure if you follow a definite plan based on the aforementioned principles. The demonstration that follows shows how to go about it.

Step 1. I first mark the top of the head and the bottom of the chin to establish the exact size of the head. I then mark the outer contour of the subject's stronger side (which in this case happens to be the right side) and place a corresponding mark on his left side. I indicate the right contour of the neck.

Step 2. Now I establish the hairline, refine the right outer contour, and show the separation of the light and shadow areas in the face as well as the left contour of the neck. I mark the shoulders, the outlines of the hair on both sides, and the right and left angle of the jawline. Finally, I indicate the neck as it joins the thorax.

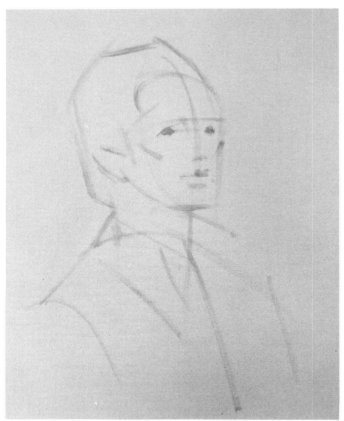 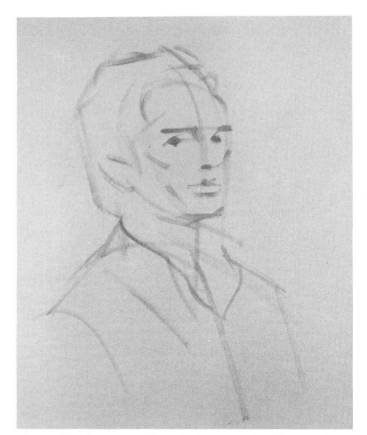

Step 3. I proceed to mark all the inner features, such as the center of the face, the irises, the bottom of the nose, the shadow underneath the lower lip, and the right and left cheekbones and the eyebrows. I further refine the hairline, place the ear, extend the shoulders, and roughly draw in the clothing.

Step 4. With a somewhat darker tone I restate and reaffirm. I shape such forms as the chin and hair to suit the subject's individuality, am more precise with the irises and brows, show the cast shadow under the chin, refine the clothing, and generally correct and sharpen the overall "map" of the head.

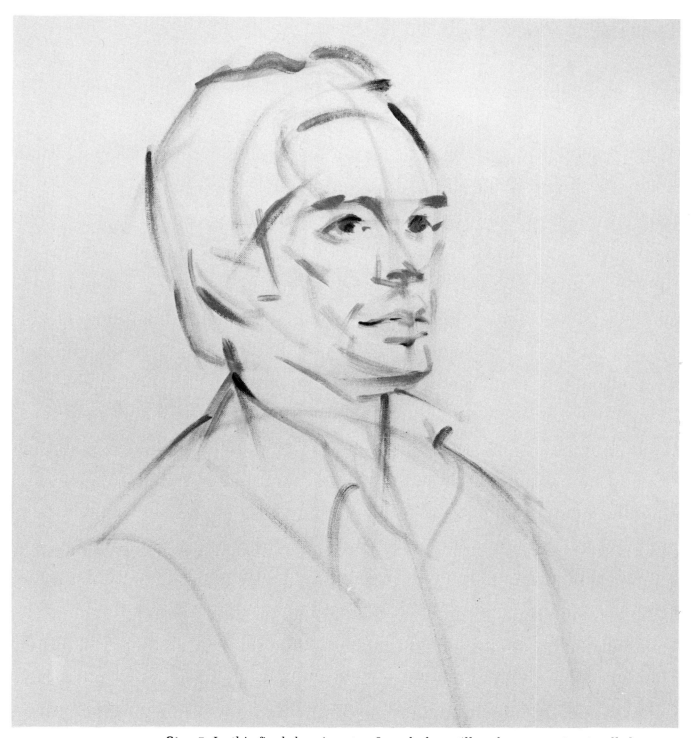

Step 5. In this final drawing step I go darker still and start putting in all the smaller planes that will help me capture the model's likeness later on. I refine the eyes so that their lids and form become more apparent, draw in the nose more carefully, show the definite masses of curl in the hair, indicate the sideburns, the collar, and the shape of the lips, redraw the bottom of the chin, and indicate where the nostril and the wing of the nose will fall. I go quite dark in several areas to stress important points and to indicate the placement of shadows in the subsequent stage. At this stage of the portrait all the problems of placement are settled to my satisfaction. If I were going to continue with this portrait, I would be ready to proceed with the painting steps at this point.

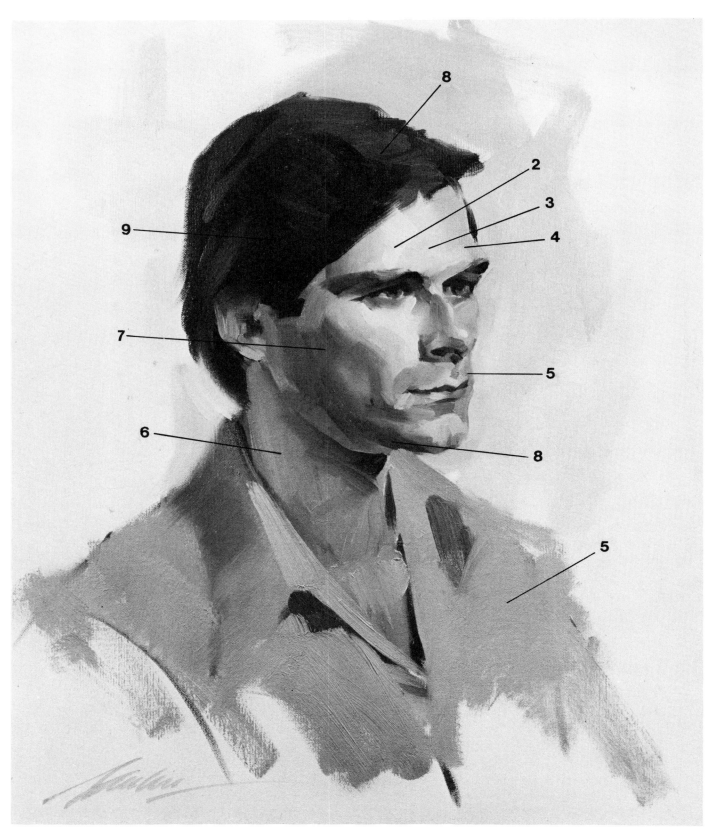

It's important for the artist to think in terms of values—since the color can't be right unless the values are right. Use the value chart printed on page 43 to help you determine the values in your own work.

4. The Values: Light, Halftone, Shadow

Values are the degrees of tonal lightness and darkness running from white to black. Keeping the value range scale shown on page 43 in view while reading this chapter will help your understanding.

For the sake of simplicity and practicality, working artists have reduced the thousands of possible values to nine so that every brushstroke placed on the canvas surface can be considered as falling into one of these nine categories. This makes the problem of mixing an *approximate* value that much easier and allows the artist to achieve a *semblance* of reality, reality itself, of course, being confined to the Master of us all.

Two factors establish the degree of any value: (1) Its inherent local tone, which is unaffected by the surrounding tones. (2) The intensity of the light illuminating it.

Let's consider the latter, which is variable compared with the former (which remains constant and is therefore not subject to the considerations that follow).

THE EFFECT OF LIGHT

In painting the head, the artist must realize that he is *not* painting eyes, ears, noses, and chins but rather *the effect of light spilling over these forms!*

Until this principle is fully swallowed and digested, the student will go on groping, fumbling, and suffering intense frustration. But once he comes to accept it as gospel, he can launch himself on the road to artistic fulfillment.

The key lies in first observing then identifying the degree, intensity, and direction of the light striking a particular object. For instance, when painting a nose forget the fact that it's made up of cartilage, bone, skin, and other tissue and seek to properly and accurately evaluate and place its lights, halftones, and shadows. The most important factor in painting the head is not getting the eyes or the mouth right, as so many artists have claimed, but the accurate separation and rendition of values ranging between light and dark.

THE SIX KINDS OF VALUE

While value is, for artistic purposes, separated into nine degrees of tonality, it is also—for the same reason—divided into six different kinds. They are:

1. *Light.* Those planes that lie at most nearly the right angle to the main light source are judged to fall within the light value and are painted accordingly.

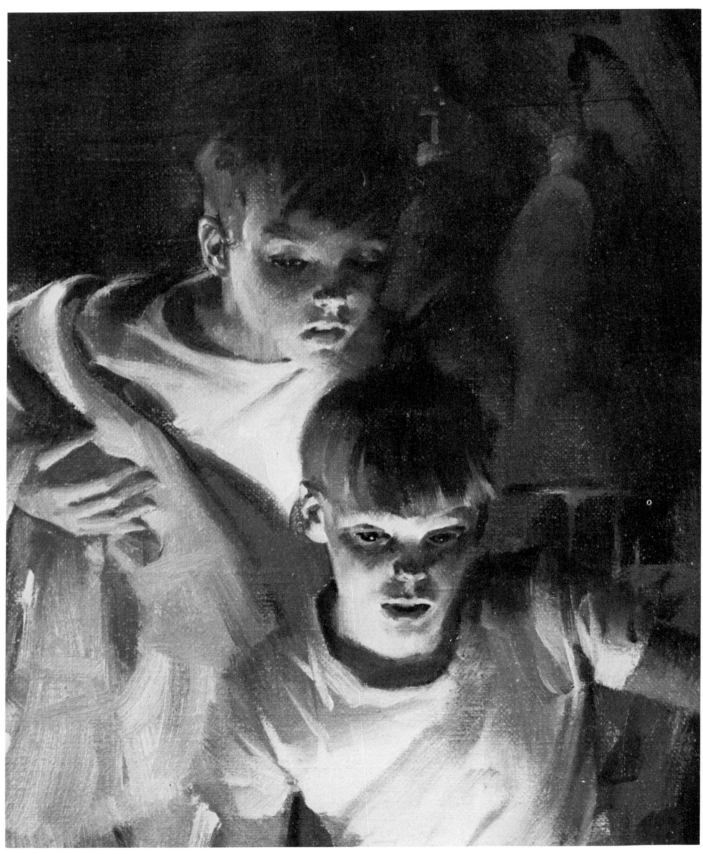

Lighting from below. (Painting reproduced courtesy the Reader's Digest Association)

4. The Values: Light, Halftone, Shadow

Values are the degrees of tonal lightness and darkness running from white to black. Keeping the value range scale shown on page 43 in view while reading this chapter will help your understanding.

For the sake of simplicity and practicality, working artists have reduced the thousands of possible values to nine so that every brushstroke placed on the canvas surface can be considered as falling into one of these nine categories. This makes the problem of mixing an *approximate* value that much easier and allows the artist to achieve a *semblance* of reality, reality itself, of course, being confined to the Master of us all.

Two factors establish the degree of any value: (1) Its inherent local tone, which is unaffected by the surrounding tones. (2) The intensity of the light illuminating it.

Let's consider the latter, which is variable compared with the former (which remains constant and is therefore not subject to the considerations that follow).

THE EFFECT OF LIGHT

In painting the head, the artist must realize that he is *not* painting eyes, ears, noses, and chins but rather *the effect of light spilling over these forms!*

Until this principle is fully swallowed and digested, the student will go on groping, fumbling, and suffering intense frustration. But once he comes to accept it as gospel, he can launch himself on the road to artistic fulfillment.

The key lies in first observing then identifying the degree, intensity, and direction of the light striking a particular object. For instance, when painting a nose forget the fact that it's made up of cartilage, bone, skin, and other tissue and seek to properly and accurately evaluate and place its lights, halftones, and shadows. The most important factor in painting the head is not getting the eyes or the mouth right, as so many artists have claimed, but the accurate separation and rendition of values ranging between light and dark.

THE SIX KINDS OF VALUE

While value is, for artistic purposes, separated into nine degrees of tonality, it is also—for the same reason—divided into six different kinds. They are:

1. *Light.* Those planes that lie at most nearly the right angle to the main light source are judged to fall within the light value and are painted accordingly.

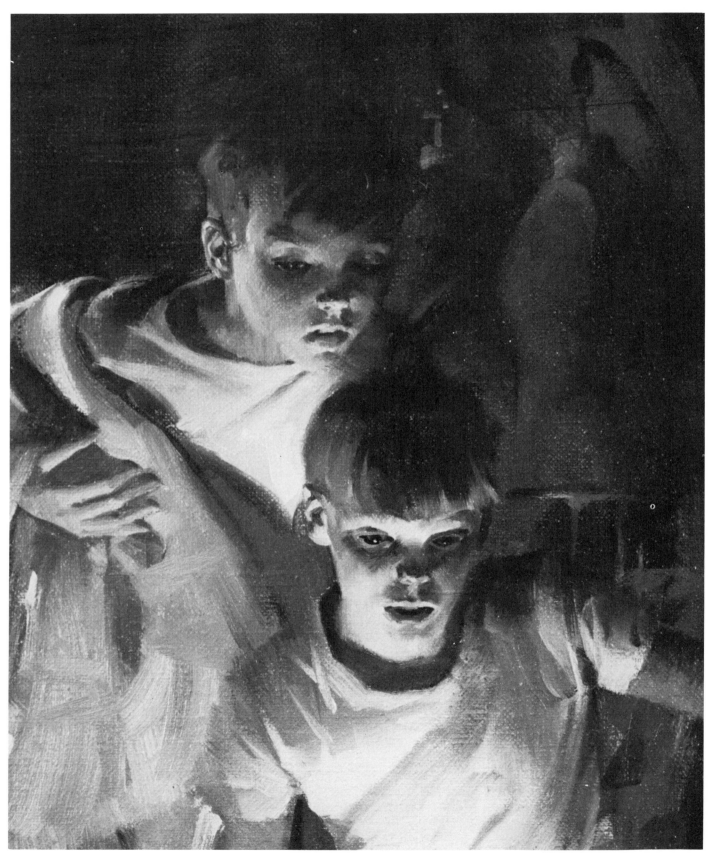

Lighting from below. (Painting reproduced courtesy the Reader's Digest Association)

2. *Halftone.* Once you tilt the plane so that it no longer faces the main light squarely but somewhat at an angle, it becomes a halftone.

3. *Shadow.* When a plane turns completely away so that *none* of the main light falls upon it, it becomes a shadow.

4. *Reflected light.* When a measure of light bounces back into the shadow—whether as a reflection of some object illuminated by the original light source or issuing from some secondary light source—this constitutes a reflected light.

A word of caution: be extremely skeptical of such lights, as they tend to appear brighter than they actually are. One must exercise harsh restraint in rendering reflected lights and *understate* rather than overstate them lest they negate the strength and solidity of the shadow areas. They are a terrific temptation for beginners and must be carefully monitored.

5. *Cast shadow.* When a light is intercepted by a form which then projects the effect of this interception onto another plane, a cast shadow is created. These cast shadows are usually *darker* than the regular shadows since they are not diluted by any reflected lights.

6. *Highlight.* A highlight appears where a plane—due to its shiny or reflective character—simply reflects back the original light source. This happens most often on the tip of a nose or in the eye, creating what photographers call a catchlight. I must warn you, however, that this is one instance in which you must take some liberties with what you think you see and paint this catchlight not smack center within the pupil—which gives the eye a glassy, unreal appearance—but instead, just at the junction between the pupil and the iris at what aerial gunners would describe as the 10 o'clock or 2 o'clock positions. If you'll visualize a watch dial you'll know exactly what I mean.

One final word: contrary to what you may have been led to believe, a highlight is not *necessarily* higher in value than a light!

VALUES ARE RELATIVE We've already established that every value occupies a specific place on the scale of nine lying between light and dark and that for painting purposes it must be consigned by the artist to one of the six values. However, it's vital to remember that each value also bears a *positive relationship to all the other values in the painting*, and this relationship is something the artist must constantly strive for.

Here are some suggestions toward this goal:

1. Establish the larger basic tonal areas such as background or hair first and in a simplified fashion, then judge the more delicate tones as they relate to these larger areas.

2. Having already selected the proper *color hue* mixture for the upcoming brushstroke, think of the subject before you in *black and white terms only* to determine its value relationships and ignore any color considerations it presents. In a way, you can compare this to switching your gaze from a color photograph to a black and white photograph of the same subject.

3. Mentally establish the lightest and darkest points on the subject and see how the other areas fall into place between these two variables.

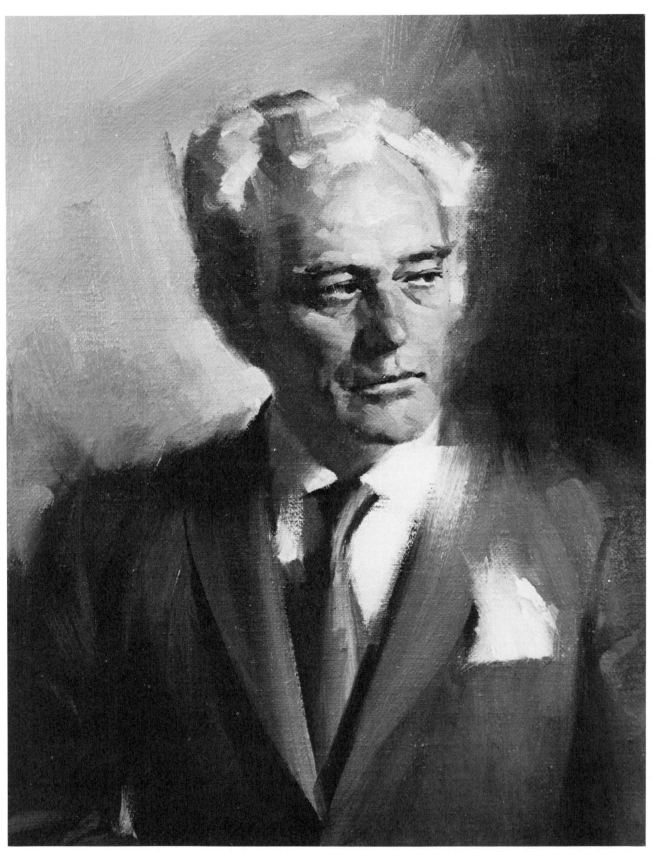

Three-quarter lighting. (Painting reproduced courtesy the Reader's Digest Association)

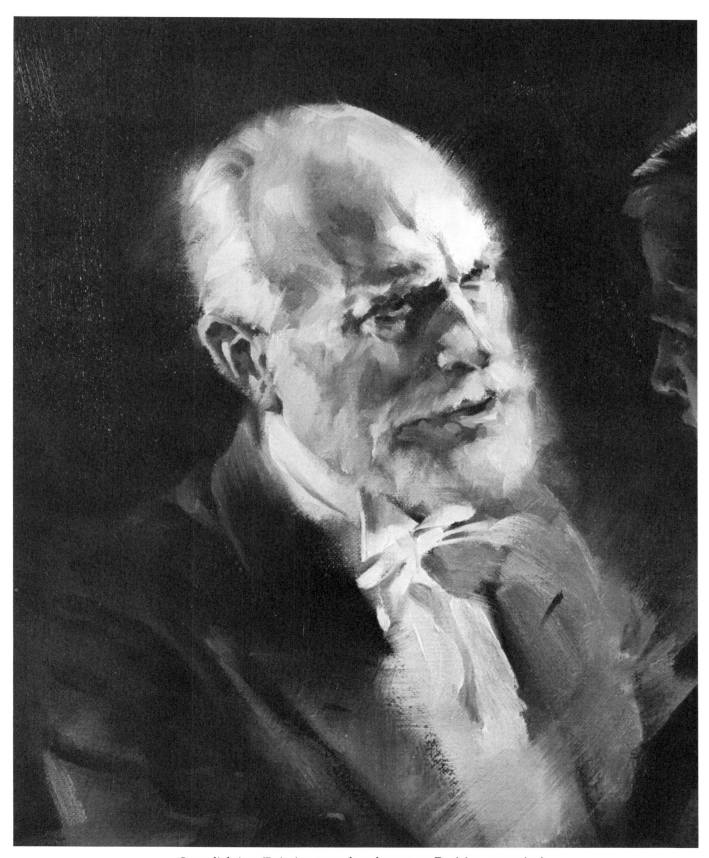

Cross-lighting. (Painting reproduced courtesy Decision magazine)

4. Having fixed a mental image of the subject's tonality, always begin painting by simply stating the big areas of darks first, working gradually toward the lights. Exercise selective judgment and *at this stage of the painting* work not in *nine* but in perhaps *three* values only! Later you'll have plenty of time to further refine the values, but in these beginning stages aim for pure shadow, halftone, and light only!

5. Experiment with such optical aids as the enclosed value scale, nine separate value cards, or a piece of red acetate which when looked through obviates all color and reduces everything to mere degrees of light and dark. Slip the value scale under the glass of your palette then try to match your tones to it as closely as possible.

Such tonal exercises will help fix the concept of tonal variation firmly in your mind and free you to pursue your painting unhampered by doubt and indecision as to the relationship of the values in your subject.

SIX DO'S AND DON'TS FOR ESTABLISHING ACCURATE VALUES

1. When painting, never judge a value independently but always in *relationship to at least two other values*! For study purposes only, however, it's perfectly legitimate to isolate a value and seek to determine its individual place on the tonal scale.

2. Always aim for a strong, simple tonal effect rather than for a complex, fragmented one which usually serves only to weaken a painting.

3. Be selective, simplify, don't attempt to render *all* the tones you see since this is beyond human capacity.

4. Pay special attention to your halftones. They are subtle, delicate creatures, and given tender loving care and attention they will respond by lending beauty, character, and sensitivity to your painting.

5. In painting highlights, paint just what you see; resist the temptation to render them lighter than they are *just because they are highlights!*

6. Keep a tight rein on your reflected lights lest they distort the shadow by their overaggressive, deadly attraction. Nothing can kill a shadow faster then a gorgeously *overstated* reflected light.

(Top Right) Diffused and reflected light. (Painting reproduced courtesy the Reader's Digest Association)

(Bottom Right) Backlighting. (Painting reproduced courtesy Decision magazine)

(Far Right) Using this value chart, analyze your own paintings and the paintings in this book and try to identify the values by number. Also use the value chart when painting from life to "read" the values in the model. This chart may be cut out of the book along the perforated line.

1

2

3

4

5

6

7

8

9

Rosa Goldfind. *Oil on canvas, 30" x 24." Rosa is a lovely girl and has sat for me many times. I painted this before a large audience at the Salmagundi Club in New York. Note the broad treatment of her thick, blond hair which most effectively frames her pale and delicate complexion.*

5. Color

In writing about color I want to stress my ignorance regarding all technological, psychological, and scientific theories regarding color. To me, color is a purely visual experience and I will speak of it only as it relates to painting the head.

I urge all my students—as I am about to urge you—to put aside all theories, formulas, and preconceived concepts and to base decisions regarding color strictly on observation alone. Nature in her infinite wisdom offers us the most beautiful and delicate color combinations and it's up to us to see and try to reproduce them with all the perception and sensitivity of which we are capable. This state of awareness is the true goal and the painting that derives from it is in a sense a by-product of this process of concentration. When painting from life, all theories on color must fall by the wayside and we must trust our eye to study and capture the color before us.

The key to color in painting is, simply, *observation!*

HUE, VALUE, INTENSITY

Each painting decision we make regarding color must be predicated on three factors: (1) its *hue*, (2) its *value*, and (3) its *intensity*.

Hue is the *name of the color,* derived from its position on the color wheel: yellow-green, blue-violet, etc.

Value is the *position of the color* on the nine-grade scale: its degree of lightness or darkness.

Intensity is the *degree of strength of the color:* its percentage of saturation of pure color.

Before laying a brushstroke of paint, the artist must first determine these three color considerations, mix an appropriate batch from the colors set out before him, then place it in its proper position on the canvas. If the result is not 100% right, he must correct it instantly!

WARM AND COOL

Every color is basically warm or cool. The warms are the yellows, reds, and oranges; the cools, the blues, greens, and violets. But within these basic, obvious categories lie infinite, subtle distinctions. A basically *cool* blue, for instance, can tend toward a warmer blue as it turns toward yellow or a cooler blue as it turns toward violet. A basically *warm* red can contain a warm orange tinge or a cool purplish one. And so on.

The grays, which basically are in neither category, can vary in dozens if not hundreds of degrees of warmness or coolness. It's one of the artist's most absorbing and challenging functions to learn to distinguish the so-called temperature of colors in order to strive for the effects of naturalness in realistic painting.

COLOR MIXING Now that you're armed with 24 colors in all—fourteen basic tints and ten premixed—you must begin the lengthy process of getting to know your color mixtures. Here are eight guidelines that will help you:

1. You must first mix then commit to memory *all* these mixtures so that when a particular challenge presents itself, you'll be able to immediately recall from your memory book the precise one you need. Instructions on mixing such charts will be found on page 61.

2. Once you know and remember these mixtures, you must remember to plan each one before making a single brushstroke.

3. Use no more than four colors (plus white) in any one mixture lest you end up with mud as the colors begin to cancel each other out. The premixed tints can be considered a single color in this regard.

4. Keep your equipment clean! When a brush becomes dirty it's hard to make a fresh decision since the product of previous decisions clings to the tool and affects all subsequent steps. So after three strokes, rinse the brush in the brush cleaner or reach for a new one.

5. Always keep a clean mixing area on the palette or you'll end up with mud. Mixing a new batch on an old permits the residue of former mixtures to act as a gatecrasher and ruin the party.

6. Keep separate area on your palette for mixing lights, halftones, and shadows. This keeps things in proper sequence and allows you to think, plan, and execute in disciplined, orderly fashion. The reverse creates chaos.

7. As already stated in Chapter 2, lay out your colors according to plan.

8. And finally, lay out and mix sufficient paint so that you won't be hampered by having to stop, squeeze, and mix just when you're going great guns. Saving on paint is the falsest of all economies since it merely dries up your creative juices.

Now that you've absorbed the eight guidelines to better color-mixing, follow these four practical steps that will help you attain your goal with firmness and resolution:

1. Always begin your mixture with that color (standard or premixed) that most closely approximates the general *hue* you're after.

2. Now gradually include the additional colors to help bring it up to the correct *value*.

3. Now, using a gray or a complementary color, mix toward the desired *intensity,*

4. Finally—observe, compare, and adjust until the accurate mixture is achieved, not on the canvas, as some teachers advocate, but on the *palette!* When it's correct on the palette, put it in its proper place on the canvas.

BLACK AND THE PREMIXED NEUTRALS If the local color of an area in the subject is black, for goodness sake paint it *black*, not some exotic mixture of ultramarine and umber, or what have you! Black is black, not an arbitrary combination of other dark colors. For some strange reason a whole spate of prejudice has evolved against

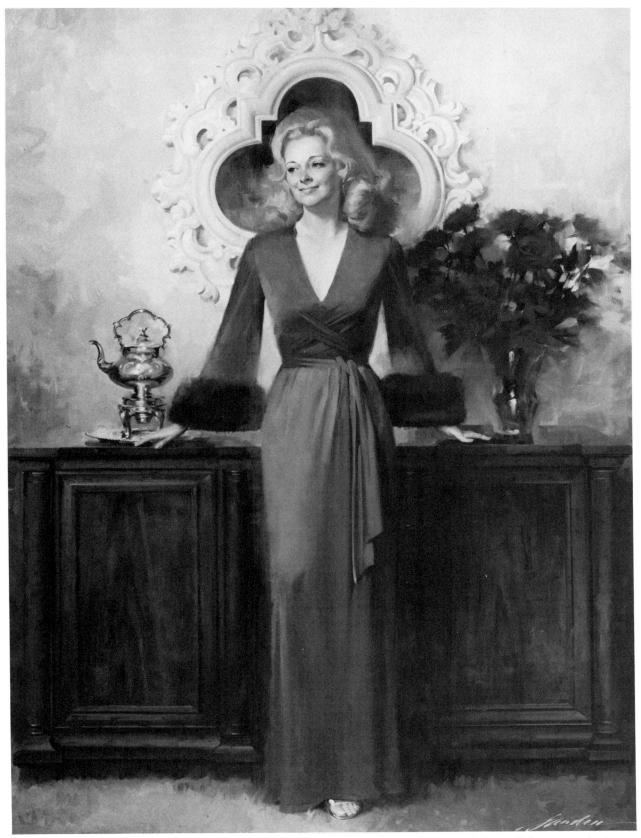

Mrs. Lloyd Davis. Oil on canvas, 74″ x 54″. Mrs. Davis is as beautiful as a movie star, and I tried to capture her radiance and elegance.

the use of good, honest black where black appears, and I frequently encounter this in my classes.

However, to reduce the intensity of other colors I strongly recommend the premixed neutrals; black here would only be detrimental. I would likewise advise you to use these neutrals *in combination* for passages of gray local color.

COLOR AXIOMS

Here is a list of assorted color axioms, each wortn its weight in gold and each carefully culled from the teachings of the master colorists of the past.

A color cannot be right until its value is right.

Color is relative to the amount of illumination falling upon it from the main light source.

Color is also affected by other influences such as the reflected light striking it.

All color upon which light falls in turn casts reflected light into other, less-brightly lit areas.

All colors in shadow receive reflected light from other colors and change accordingly.

A local color retains its identity to some degree even in shadow.

No color in shadow can be more intense than it would be in light or in halftone. However a color in halftone can be *more* intense than in light.

Adding a complementary color serves to gray down its complement.

Gray, neutral, cool color tends to recede while warm, intense color tends to advance.

Sound color judgments are based on *observation* rather than on systems, rules, or theories!

HOW TO PREPARE THE PREMIXED COLORS

The materials required to prepare the premixed colors include the following:

1. Mixing palette, which consists of a piece of clear glass, 11″ x 11″.

2. Mixing chart, a sheet of paper divided into 86 units, each 1″ in length. I slip this sheet beneath the glass and use it as a guide with which to measure out the amounts of paint to be used in each mixture.

3. Ten empty 1-pound tubes.

4. Preglued labels.

5. A painting knife.

6. Canvas pliers.

7. A razor blade.

8. A box of tissues.

9. A can of turpentine for cleaning up.

10. Your standard colors plus raw sienna from which to prepare the mixtures.

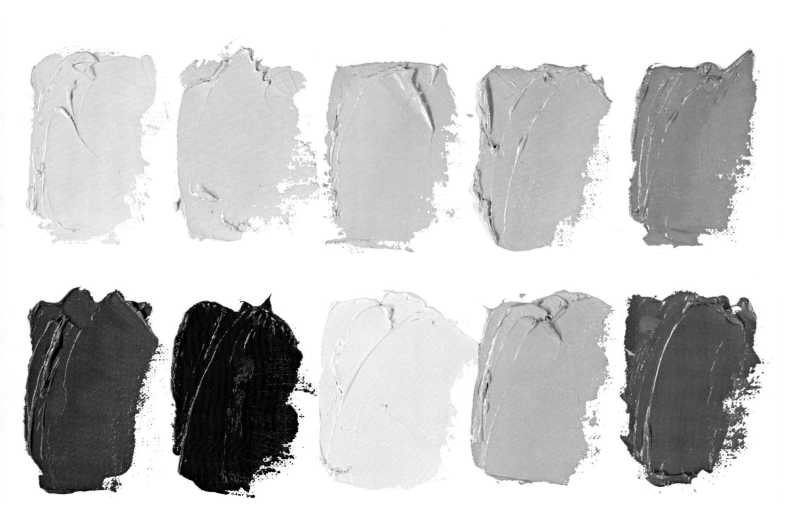

Here's my specially formulated palette of colors that I have premixed in order to save time and for the sake of convenience. It consists of seven flesh tones and three neutrals. By mixing one premixed color with one color from the standard palette, you can achieve many interesting flesh-tone combinations. Reading from left to right in the top row they are: Light 1, Light 2, Light 3, Halftone 1, and Halftone 2. And from left to right in the bottom row: Dark 1, Dark 2, Neutral 3, Neutral 5, and Neutral 7.

(Right) My ten special colors are now manufactured and available for purchase in ready-to-use form under the tradename "Pro Mix" colors (the full name is John Howard Sanden's Pro Mix Color System). You may obtain a set of ten tubes by writing to the distributor: S.E.E., Incorporated, 881 Seventh Avenue, New York, N.Y. 10019. The same firm can also supply you with individual tubes when you run out of certain colors. The manufactured colors are fine quality, carefully formulated, and they save you all the bother of mixing and tubing.

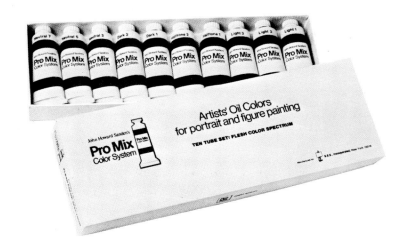

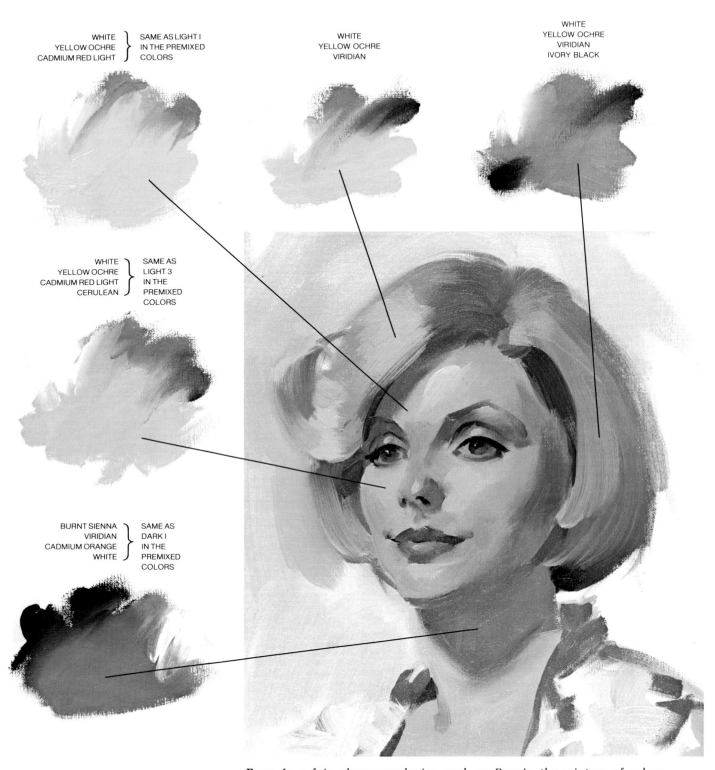

WHITE
YELLOW OCHRE
CADMIUM RED LIGHT
} SAME AS LIGHT 1
IN THE PREMIXED
COLORS

WHITE
YELLOW OCHRE
VIRIDIAN

WHITE
YELLOW OCHRE
VIRIDIAN
IVORY BLACK

WHITE
YELLOW OCHRE
CADMIUM RED LIGHT
CERULEAN
} SAME AS
LIGHT 3
IN THE
PREMIXED
COLORS

BURNT SIENNA
VIRIDIAN
CADMIUM ORANGE
WHITE
} SAME AS
DARK 1
IN THE
PREMIXED
COLORS

Rosa. *In a fair, clear complexion such as Rosa's, the mixture of colors equivalent to Light 1 provides the cleanest, purest flesh color for the overall tone in a light area such as the forehead. It contains no cool or gray accents at all. It's also interesting to note that natural blond hair is not bright yellow but rather a combination of dull, cool, greenish tones in the highlights and some darker greens and black in the shadows.*

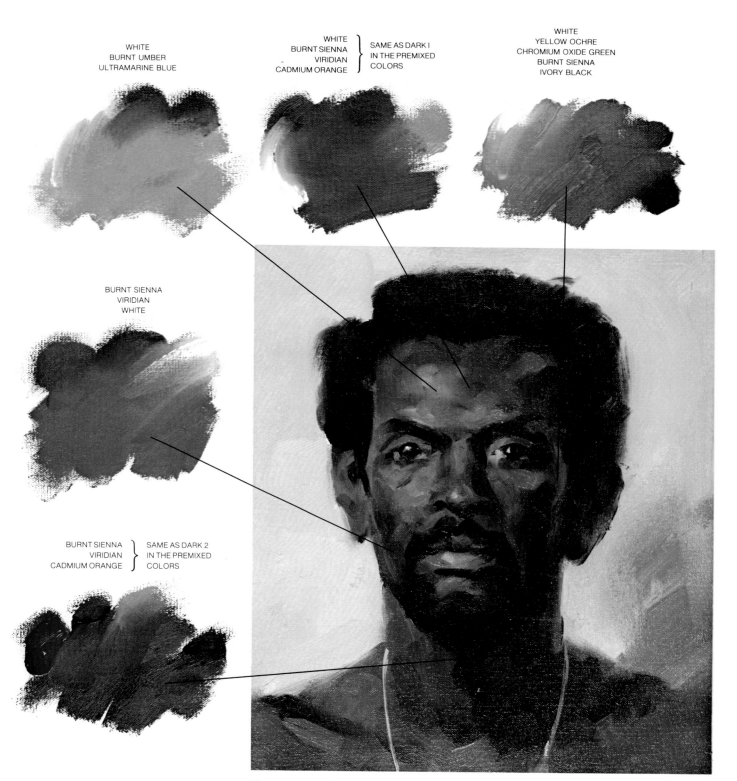

WHITE
BURNT UMBER
ULTRAMARINE BLUE

WHITE
BURNT SIENNA
VIRIDIAN
CADMIUM ORANGE } SAME AS DARK I
IN THE PREMIXED
COLORS

WHITE
YELLOW OCHRE
CHROMIUM OXIDE GREEN
BURNT SIENNA
IVORY BLACK

BURNT SIENNA
VIRIDIAN
WHITE

BURNT SIENNA
VIRIDIAN
CADMIUM ORANGE } SAME AS DARK 2
IN THE PREMIXED
COLORS

Normann. *Dark-skinned subjects tend to exhibit grayish or bluish high-lights. In this instance, the reflected light is strongly on the green side. In painting dark skin the tendency is to go lighter in fear of losing the nuances of modeling. However, the key to success in this challenging area is to keep those dark portions just as deep and rich as they actually appear. Another factor to remember is to provide an arresting interplay of cool highlights against the warm colors surrounding them. A final note: see how low in value is the actual highlight as seen on Normann's forehead. It's no higher than 7 on the value scale (page 43).*

WHITE
YELLOW OCHRE
CADMIUM RED LIGHT
CERULEAN
} SAME AS LIGHT 2
IN THE PREMIXED
COLORS

WHITE
YELLOW OCHRE
IVORY BLACK
BURNT SIENNA

IVORY BLACK
BURNT UMBER
ALIZARIN CRIMSON

WHITE
YELLOW OCHRE
CADMIUM RED LIGHT
CADMIUM ORANGE
CHROMIUM OXIDE GREEN
} SAME AS
HALFTONE 2
IN THE
PREMIXED
COLORS

WHITE
YELLOW OCHRE
VIRIDIAN
CADMIUM RED LIGHT
} SAME AS
HALFTONE I
IN THE
PREMIXED
COLORS

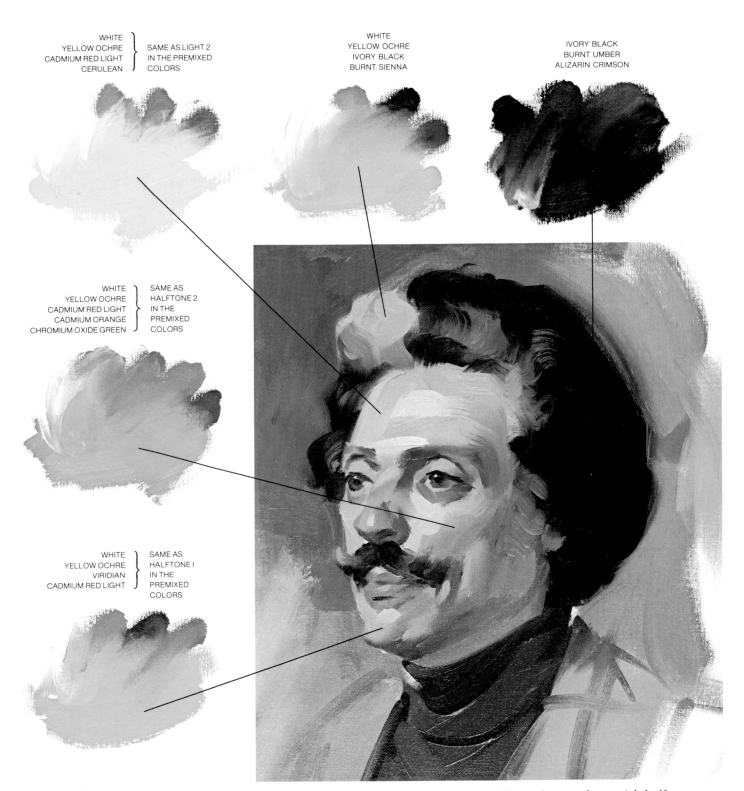

Sol. The lower portions of men's faces usually tend toward greenish half-tones due to the presence of the underlying beard. Besides, Sol has a naturally swarthier complexion than Rosa, which is another factor in a generally grayer, cooler combination of flesh mixtures in this portrait. The top right mixture produces one of the lowest dark tones possible. However, in this case it possessed enough warmth to include burnt umber and alizarin.

Anne-Marie Barr. *Oil on canvas, 38″ x 30″. Direct side-lighting is rarely used in portraiture, but it's interesting to paint and there are definitely times when it should be employed. In order to move the flowers as close into the composition as I wanted, I had to remove one arm from the chair (I didn't actually wreck the chair, I just painted it that way). (Courtesy Portraits, Inc.)*

The Straw Hat. *Oil on canvas, 30" x 24". While most of this book deals with painting the head, the principles and procedures are exactly the same for figure painting. This provocative young lady posed for me in the studio, with a powerful spotlight shining down to create a sunlight effect. Then we went out into Central Park where I made some color notes for the background. (Collection the artist)*

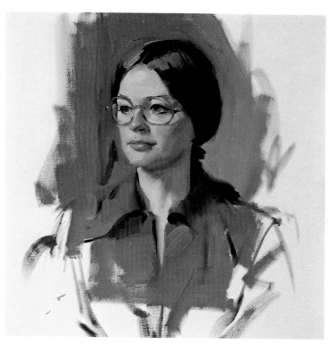

Elizabeth. *Oil on canvas, 24" x 20". This rapid study of my wife was painted one Sunday afternoon while our three-year-old daughter was napping in the studio. Note how many cool halftones lie around Elizabeth's mouth, chin, and forehead, with the warm areas centered on her mouth, cheeks, and nose.*

Priscilla. *Oil on canvas, 30" x 24". Here I completed the head before adding the glasses. See pages 92–93 for a demonstration of this procedure. Priscilla had a gentle, sensitive look which I tried to capture. Several other paintings of her, in different moods, appear throughout this book.*

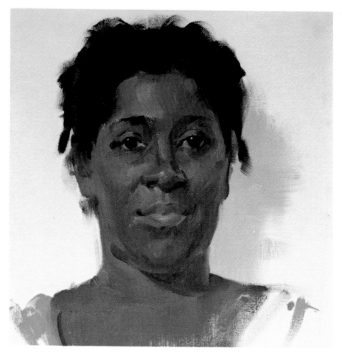

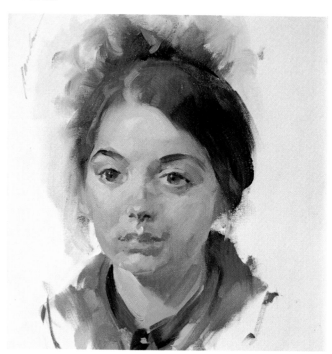

Dolores Barnes. *Oil on canvas, 18" x 14". The lights on this model's complexion emerge as a really bluish tone which makes for an interesting contrast with the warm, brown halftones. Note how far from white is the color of the "whites" of Dolores' eyes. Most students tend to paint these far too light.*

Head study. *Oil on canvas, 18" x 14". I painted this while I was a student in Samuel Oppenheim's class at the Art Students League. The model was another student, and she had a marvelous melancholy, waiflike look .*

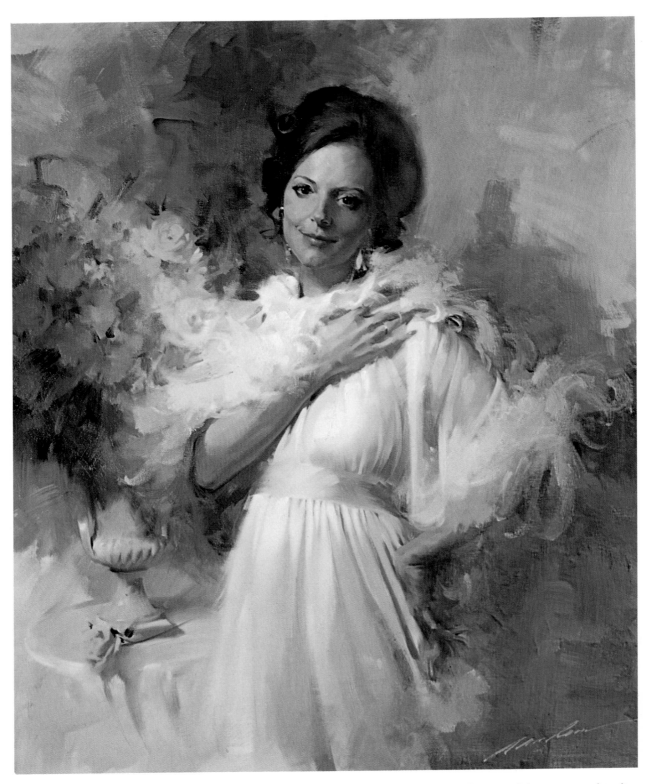

Sunny Griffin. *Oil on canvas, 42″ x 34″. This beautiful girl is one of the most sought-after photographer's models in New York. She struck this stylish pose instinctively, and I tried to capture her grace, chic, and exuberant personality. The marabou stole was so evanescent—it flowed into and out of the background and was lots of fun to paint. (Collection the artist)*

Each of the ten premixed colors calls for a different combination of colors. I squeeze out the proper amounts of paint according to formula onto the top sheet of glass following the numbers on the chart, then mix the ribbons of paint together thoroughly and put them up in the tubes.

For example, Light 1 calls for 74 units of white, 10¾ units of yellow ochre, and 1¼ units of cadmium red light, for the total of 86 units required to fill the 1-pound tube. This means that I squeeze ribbons of Permalba white over the lines until I reach 72 units, which as you can see, extends to the end of line 12. I then squeeze 10¾ units of yellow ochre which will extend ¾ into line 15. The remaining 1¼ units will be filled with cadmium red light. This combination of colors when well mixed together will make up a 1-pound tube of Light 1.

Here are the formulas for the ten premixed colors. Each combination will, naturally, add up to 86 units.

Premixed Colors	Tube Colors	Units
LIGHT 1	White	74
	Yellow ochre	10¾
	Cadmium red light	1¼
LIGHT 2	White	71
	Yellow ochre	10¾
	Cadimum red light	2¾
	Cerulean blue	1½
LIGHT 3	White	68½
	Yellow ochre	10
	Cadmium red light	5
	Cerulean blue	2½
HALFTONE 1	White	61
	Yellow ochre	14
	Viridian	9
	Cadmium red light	2
HALFTONE 2	White	57
	Cadmium red light	12
	Yellow ochre	9
	Chromium oxide green	4
	Cadmium orange	4
DARK 1	Burnt sienna	30
	White	22½
	Viridian	20
	Cadmium orange	13½
DARK 2	Burnt sienna	44
	Viridian	29
	Cadmium orange	13
NEUTRAL 3	White	82
	Yellow ochre	3
	Ivory black	1
NEUTRAL 5	White	70
	Yellow ochre	9
	Ivory black	7
NEUTRAL 7	White	50
	Ivory black	24
	Raw sienna	12

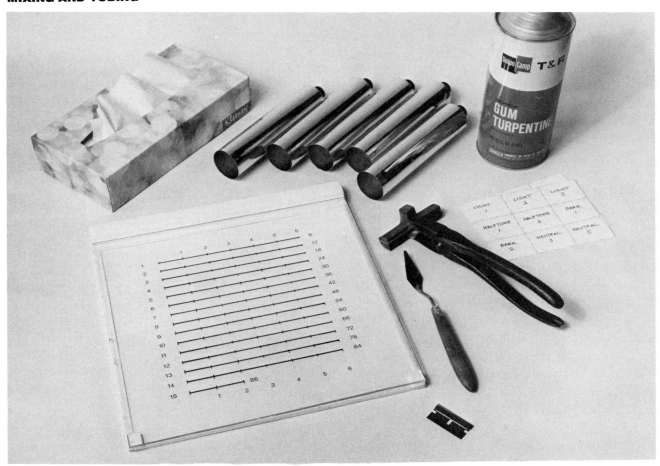

1. *Set up the materials: a mixing palette with chart slipped beneath the glass ready for measuring, a box of tissues, empty 1-pound tubes, turpentine, preglued labels, canvas pliers, painting knife, razor blade.*

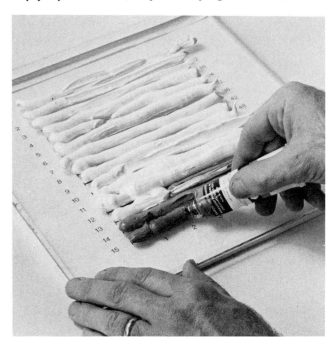

2. *Squeeze out the proper amount of paint according to formula.*

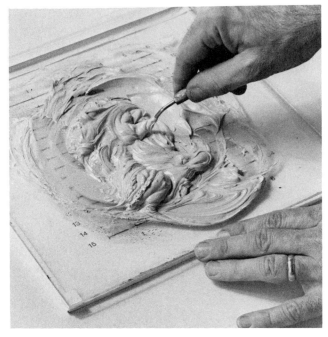

3. *Mix the complete batch thoroughly with the painting knife.*

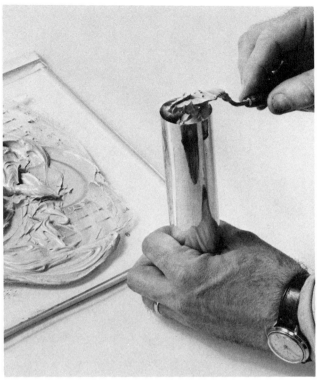

4. *Holding the tube cap down, fill the tube completely with the mixture, then tap your fist several times against the table (remembering to hold the cap a trifle above the surface) in order to force the paint well down into the tube.*

5. *Squeeze the bottom of the tube together with your fingers and wipe away the excess paint with a tissue.*

6. *With the canvas pliers, grip the tube ¼″ from the end and make two turns forward so that the tube is firmly crimped at the bottom.*

7. *Affix the previously prepared preglued label—the paint is now ready for use.*

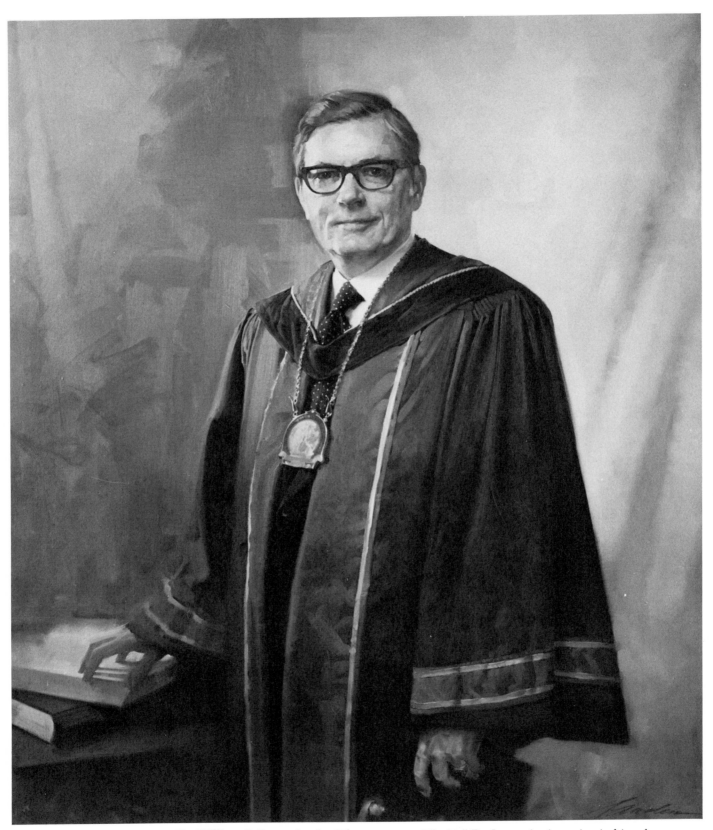

Dr. William P. Longmire, Jr. *Oil on canvas, 46"x 38." Dr. Longmire is posing in his robe and medallion as President of the American College of Surgeons. The robe is brilliant red and blue, and I had to really tone it down to control it. We both felt that an absolutely plain, neutral background was necessary. (Collection the American College of Surgeons)*

LEARNING ABOUT COLOR

To aid you in learning how the colors on the suggested palette behave in mixtures, I've prepared a series of charts to help guide you in performing certain exercises and manipulations which hopefully will instill in you the urge to delve deeply into the nature and properties of the colors you will be using in painting the head.

The first of these is a series of mixtures employing the *standard* colors to mix grays, violets, browns, greens, reds, yellows, and blues. The second chart shows means of warming, cooling, lightening, darkening, intensifying, or reducing your *premixed* colors, and the third, some suggested color combinations for painting dark skin using both *standard* and *premixed* colors. In certain instances the following abbreviations are employed:

ULT	Ultramarine blue	BL	Ivory black
CER	Cerulean blue	N7	Neutral 7
V	Viridian	N5	Neutral 5
COG	Chromium oxide green	N3	Neutral 3
AC	Alizarin crimson	D2	Dark 2
BU	Burnt umber	DI	Dark 1
BS	Burnt sienna	H2	Halftone 2
CO	Cadmium orange	H1	Halftone 1
VR	Venetian red	L3	Light 3
CRL	Cadmium red light	L2	Light 2
YO	Yellow ochre	L1	Light 1
CYL	Cadmium yellow light	W	Permalba white

I suggest that you rule out pages on canvaslike paper into 1″ squares, label each one, and make the mixture indicated at the value indicated. Paint the mixture into the square and allow it to dry. After completing all the mixtures at the indicated value, repeat the process, two values lighter in all cases. When you've completed all the mixtures, assemble them in a looseleaf notebook for permanent reference.

COLOR MIXTURES FROM THE STANDARD PALETTE

GRAYS

ultramarine burnt umber white **value 4**	cerulean burnt umber white **value 4**	ivory black white **value 4**	ivory black yellow ochre white **value 4**	ivory black burnt umber white **value 5**	burnt umber white **value 5**

VIOLETS

alizarin crimson white **value 5**	alizarin crimson cadmium red lt. white **value 5**	alizarin crimson venetian red white **value 5**	alizarin crimson ultramarine white **value 5**	cadmium red lt. ultramarine white **value 5**	venetian red ultramarine white **value 5**

BROWNS

burnt umber white **value 7**	burnt umber yellow ochre white **value 7**	burnt sienna viridian white **value 7**	burnt sienna yellow ochre white **value 7**	ivory black yellow ochre burnt sienna white **value 8**	ivory black burnt sienna white **value 8**

GREENS

chromium oxide green cadmium yellow lt. **value 5**	chromium oxide green white **value 5**	chromium oxide green yellow ochre **value 7**	chromium oxide green cadmium orange **value 7**	viridian cadmium yellow lt. **value 5**	viridian white **value 5**

REDS

cadmium red lt. cadmium yellow lt. **value 5**	cadmium red lt. cadmium orange **value 6**	cadmium red lt. venetian red **value 7**	cadmium red lt. burnt sienna **value 7**	cadmium red lt. yellow ochre **value 6**	cadmium red lt. burnt umber **value 8**

YELLOWS

cadmium yellow lt. white **value 1**	cadmium yellow lt. yellow ochre white **value 3**	cadmium yellow lt. yellow ochre **value 4**	cadmium yellow lt. cadmium orange **value 3**	yellow ochre white **value 4**	yellow ochre cadmium orange white **value 4**

BLUES

ultramarine white **value 7**	ultramarine ivory black white **value 8**	ultramarine ivory black **value 9**	ultramarine viridian **value 6**	cerulean white **value 6**	cerulean ivory black white **value 7**

venetian red
viridian
white
value 5

ivory black
burnt umber
white
value 8

viridian yellow ochre **value 7**	viridian cadmium orange **value 7**	ultramarine cadmium yellow lt. **value 5**	ivory black cadmium yellow lt. **value 7**	ivory black yellow ochre **value 7**	ultramarine yellow ochre white **value 7**
cadmium red lt. alizarin crimson **value 8**	cadmium red lt. ivory black **value 8**	alizarin crimson cadmium yellow lt. **value 7**	alizarin crimson burnt sienna **value 8**	alizarin crimson burnt umber **value 8**	alizarin crimson ivory black **value 9**

yellow ochre cadmium orange **value 5**	cadmium yellow lt. burnt umber white **value 4**	yellow ochre burnt umber **value 7**

cerulean viridian **value 8**	ivory black white **value 6**

**Flesh Tone Mixtures
from the Premixed Colors**

Cool halftones

Warm halftones

Halftone 1

Halftone 2

To warm, add

L3 YO CRL H2

CRL VR CO AC

To cool, add

COG V CER N5

N5 COG V

To lighten, add

N3 L2 W

L3

To darken, add

BL D1

D1

To increase intensity, add

YO, V
CRL

YO, CO,
CRL

To reduce intensity, add

N5

N5

NOTE: An 11″ x 32″ copy of this chart, printed on heavy paper ready for painting, is included with each set of my Pro Mix colors (see page 49).

Highlights

☐	**Light 1**

AC	CRL	CYL

CER

W

L2

YO, CRL	CO

N3	H1

Basic lights

☐	**Light 2**

CRL	CYL	YO

CER	H1	N3

W

H2

YO, CRL

N3

Warm lights

☐	**Light 3**

CRL	VR

CER	N5

L2

H2

YO, CRL	CO

N5	H1	CER

	Shadows				Darkest accents	
			Dark 1			**Dark 2**
To warm, add	BS	CRL	AC	CO	AC	
To cool, add	COG	V	N7		V	
To lighten, add	H2	L3			D1	
To darken, add	D2	BU			BU	
To increase intensity, add	BS, CO				BS	
To reduce intensity, add	N7	V	COG		ULT	

Mixtures for Painting Dark Flesh

SHADOWS

Burnt umber, or
Burnt umber and burnt sienna, or
Burnt umber and alizarin crimson

DARKEST ACCENTS

Burnt umber and alizarin crimson, or
Black and alizarin crimson, or
Burnt umber, alizarin crimson, and ultramarine

HALFTONES

Dark 2 plus:

To Cool
Viridian, or
Ultramarine, or
Neutral 7

To Warm
Cadmium red light, Venetian red, burnt sienna and white, or
Alizarin crimson and white

LIGHTS

Dark 1 plus:

To Cool
Chromium oxide green and white

To Warm
Cadmium red light, or
Burnt sienna, or
Venetian red

For Golden Color
Cadmium orange, or
Yellow ochre

HIGHLIGHTS

Cool
Burnt umber, ultramarine, and white

Warm
Cadmium orange, chromium oxide green, and white, or
Burnt sienna, yellow ochre, and white, or
Burnt umber, yellow ochre, and white

Greenish Reflected Light
Yellow ochre, chromium oxide green, burnt sienna, black, and white

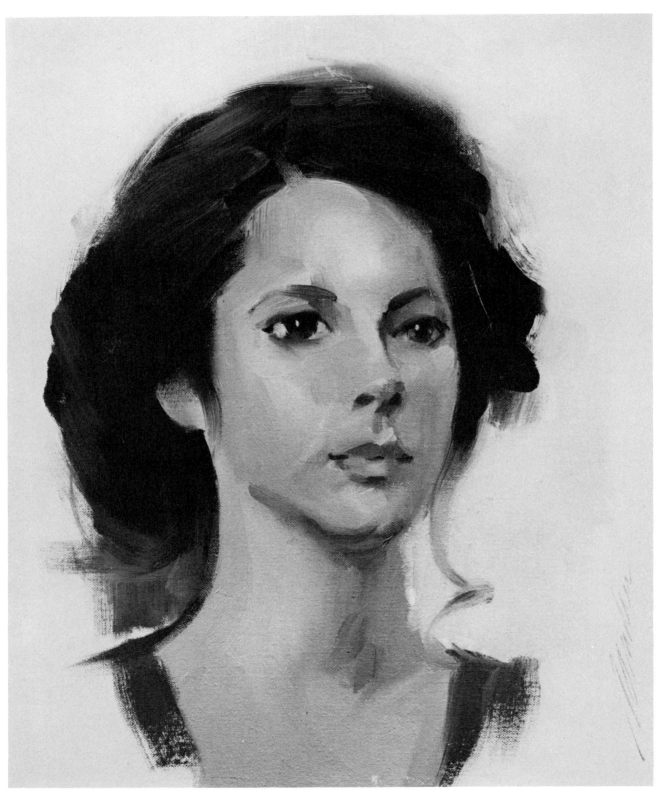

Head Study. *Oil on canvas, 18" x 14". The premier coup method works only if the entire effort proceeds correctly from start to finish. This dictates careful deliberation before any brushstroke is placed. If you stop to fix, modify, or noodle about to any great degree, you lose all the charm and effectiveness of the portrait and most certainly its fresh and spontaneous look.*

6. Principles of Painting Procedure

The method of painting that I practice and advocate is called *alla prima*, from the Italian, or (as I prefer it) *premier coup*, from the French. This is loosely translated to mean a direct or spontaneous attack.

PREMIER COUP Basically, this means that I attempt to execute a finished painting from the very first stroke, without such traditional intermediate steps as toning, underpainting, glazing, or scumbling. And I try to complete the entire painting in one sitting, if possible.

In this method, the artist marshals all his concentration, alertness, and energy so that every stroke of the brush becomes part of the finished statement, and it becomes unnecessary to correct or modify in subsequent sessions. He leaves nothing to chance, but concentrates all his effort upon getting it right the first time. In a way, this method represents a kind of Evel Knievel leap over a chasm—the performer gets only one chance to do what he has to do.

Naturally, this is the ideal. You'd have to be a Leonardo to achieve it each time you step up to your easel. Nevertheless, it's the ideal you should shoot for and keep uppermost in your mind when you come face-to-face with the blank canvas.

Having thoroughly immersed myself in this notion, I do my best to stick to it. I proceed with the concept that an invisible gun is pointed at my head, forcing me to get it right—*now*—and not leave myself room for improvement at some later time. I sometimes fail, but over the years I've found that my most meaningful paintings have been those that I've gotten right *from the very beginning*. Conversely, if I get off on the wrong foot and keep on going, the picture invariably turns out badly. Therefore, if things don't go well at once, I rub out and begin anew.

One of Sargent's most effective pictures at New York's Metropolitan Museum, the portrait of Mr. and Mrs. Isaac Newton Phelps Stokes, represents a number of false starts, each of which the artist rubbed out in dissatisfaction. But the final effort resulted in a magnificent painting. He could have spent the time correcting and modifying his original conception, but he chose to make a fresh start each time and to get it right from the first stroke. This typifies the concentration, energy, and alertness dictated by the *premier coup* method, the motto of which might be: get it done; get it done right; get it done right from the very beginning.

Incidentally, this principle of striving for the finished effect from the very first stroke applies equally to paintings of any size, subject, or degree of complexity. Even if I'm confronted by an involved composition

containing several figures, I work on one section at a time until it's done; then I proceed to a different area of the picture.

Now let's consider the nine principles governing this method of painting:

Principle 1: Start with a White, Untoned Canvas. I paint on a white, untoned canvas, since this seems to reflect the colors in the truest and clearest fashion. Another reason I rarely tone the canvas is that I use a white palette; white canvas serves as an accurate match for the palette, so that I can take the paint from palette to canvas knowing beforehand how the paint will appear on the surface.

I also enjoy the feel of the bare canvas texture against my brush—this seems most sympathetic to my efforts.

For the *premier coup* method, which calls for a single layer of paint laid in as swiftly as possible, toning the canvas in advance is a contradiction in terms, and useless. Contradictory because it implies a preliminary judgment prior to observation. Useless, because the subsequent paint has to be a correct and final statement, without support from the preliminary toning.

Principle 2: Establish Your Goal. There may be fifty or more goals that artists seek in the execution of their paintings: achieving a beautiful color scheme, defining the esthetic qualities of a scene, or portraying a mood are a few.

Make it your goal to capture the *character* of your subject in the simplest, most direct, most immediate fashion possible! One might call this a kind of "impressionism," but not in the sense that the term is customarily used in painting. What I advocate is simply that you *paint what you see.* In short: (1) be as accurate and true as you can in evaluating the appearance of the subject before you; and (2) reproduce this image as simply and faithfully as you can, while exercising the greatest degree of economy to achieve your statement.

In order to paint what you see, you must accurately capture both the subject's *inner* and *outer* traits, contours, and dimensions, all of which together constitute his *total* character. At the same time, you must inject your own indelible personality into the effort, so that the painting becomes *your personal statement*—your reaction to, appreciation of, and pictorial reproduction of the divine creation that is a human life.

If three words are to exemplify your goal in painting, let them be *simplicity, directness,* and *accuracy.*

Principle 3: Make Every Stroke Count. The method of painting I urge you to follow may be compared to a surgical procedure in which the patient's life hangs on the surgeon's ability to make his every move vital and meaningful to the success of the operation. Fumbling, dilly-dallying, daydreaming, and indecision have no room in the *premier coup* method of painting. One stroke of the brush must do what thirty strokes may lead to in another, less disciplined technique.

Therefore, in order to make every stroke count:

1. Use the biggest brush for the job at hand! How do you tell if it's the proper brush? If it feels a bit *too* large, then it's exactly right.

2. Make sure that every brushful of paint you bring to the canvas will be correct in four ways—hue, value, intensity, and position—before you

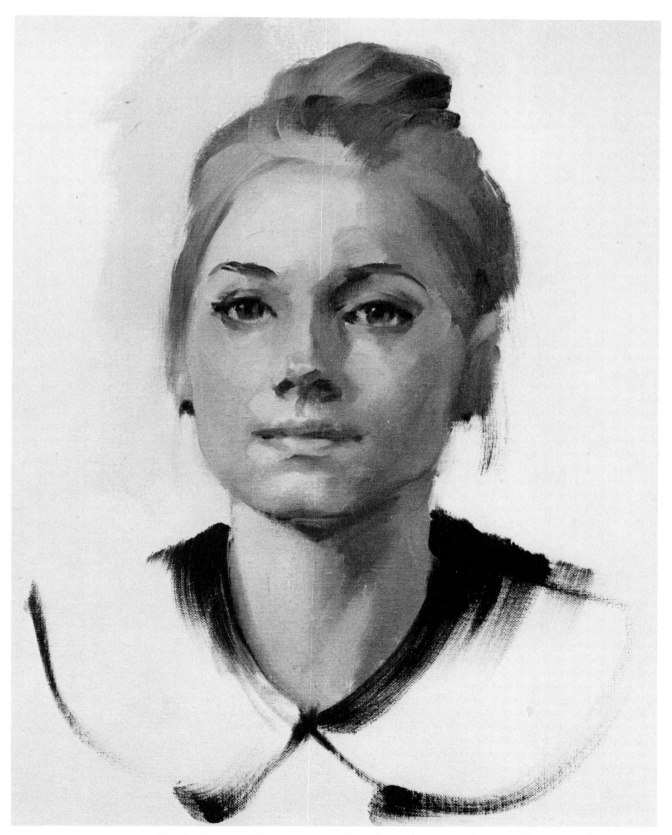

Marsha Lowery. *Oil on canvas, 18″ x 14″. A prime requisite is a white, untoned canvas. Transferring the paint mixture from my white palette to the bare white canvas lets me know exactly how the stroke will appear on the surface. This wouldn't work if I toned my canvas or underpainted heavily.*

touch the canvas. Since these four factors are riding on every stroke you apply, this necessitates much thinking and preplanning and precludes any purposeless sloshing and slapping about of paint.

How do you ensure that the *hue, value* and *intensity* of a brushful of paint are correct? By staring intently from subject to palette and back again until you've mixed the exact combination on the palette. In loading the brush, remember that the *color* of a mound of paint can never be correct if its *value* isn't correct.

How do you ensure its proper *position* on the canvas? Follow the example of the great John Singer Sargent. Sargent's brush—in the words of an observer—"hung in the air" as the master took careful and deliberate aim before allowing it to settle in its appropriate spot on the canvas. It's almost like aiming a rifle at a target: a fraction of an inch off is enough to spoil the effect. A miss is as good as a mile.

3. Always paint with the assumption that what you're placing on the canvas is there to stay and not to be changed later! A painting is very much like a mosaic, with each brushstroke representing a separate, but most important tile; seen together, all the tiles constitute the total picture. Tiles can't be covered up, but must be correct from the start—and so must every stroke of your brush. Therefore, the color and placement of each stroke must be the product of a well-thought-out decision. If it isn't the correct hue, value, intensity, and position, it doesn't belong on your canvas in the first place.

4. Don't be afraid to rub out and begin anew! An error many beginners fall into is an obstinate determination to follow a course even if it's the wrong one. Rather than begin all over again, they'll noodle, dabble, and plod along, thus compounding their original error until the painting is a total fiasco, beyond redemption. An important axiom to remember is: *one false statement leads to another!* If the original strokes are *almost* right, but not quite right, you'll end up with a painting that's *almost* right—and therefore totally wrong. This is true because every stroke is conditioned by those lying beneath it and next to it. So, every stroke must be the right stroke. If not, rub out and start over!

If you see an area that appears wrong, even after the paint has dried, don't hesitate to rub it out. The best solvent I've found for this purpose is chloroform, obtained at any drugstore and used on the area in question. It seems to do the job well and doesn't affect the canvas priming. I dab the solvent on full strength, wait for the dried paint to crumble, then wipe it away, leaving the canvas surface bare for repainting. Naturally, I observe all the rules governing the use of chloroform, which can be dangerous: I open the windows and stay away from fire. An exhaust fan helps too. A blast of air from an open window, while you're chloroforming your canvas, will keep both *you* and *your painting* fresh and alive.

Making every stroke count by following the four rules I've just mentioned won't necessarily assure the success of your painting; but letting a few incorrect strokes remain on the canvas will guarantee its failure.

Principle 4: Don't Waste Effort. While the *premier coup* method goes hand-in-hand with a speedy execution, it's far, far more important to be deliberate and accurate than merely fast. Therefore:

1. Think before you mix and place a brushstroke. Three precise strokes

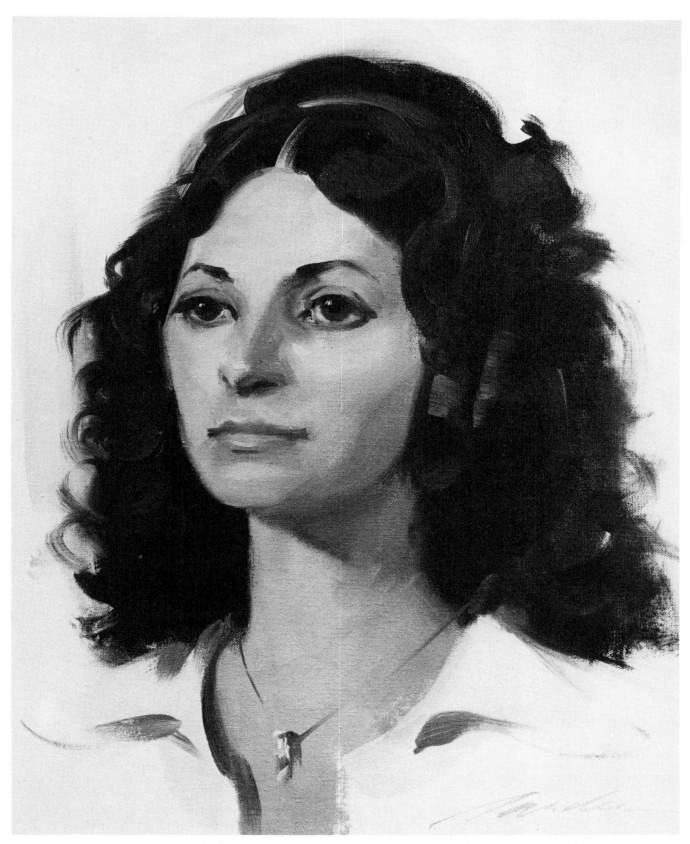

Head Study. *Oil on canvas, 18" x 14". The treatment of the nose and mouth demonstrates the principle of making every stroke count. Each of these features has been painted with a minimum of brushstrokes yet each is absolutely vital to the total effort.*

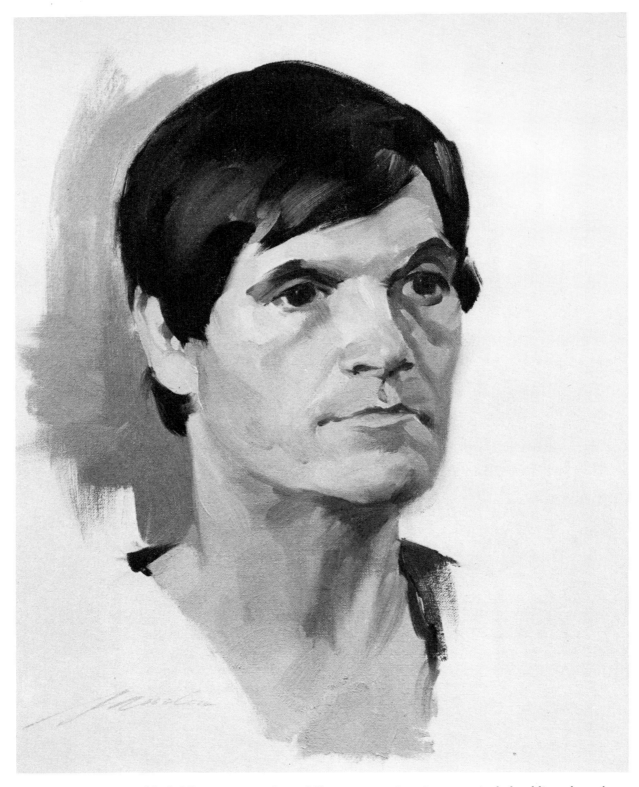

Neal. *Oil on canvas, 18" x 14." If you ran two imaginary vertical plumblines down from the inside borders of Neal's irises, you would find that they just about touched the corners of his mouth. This is an excellent device for locating and placing the various elements in the head while drawing in the beginning stages of the portrait.*

during a painting session are more productive than a hundred sloppy, unplanned, "spontaneous" ones. Think before you act.

2. Observe sharply; be deliberate and decisive. Learn to observe and then evaluate the effects of these observations. Reach deep within you and ask yourself: Why can't the first stroke I make be the *final* statement I really wish to make about some particular part of the subject?

Personally, I don't want to see a single thing on my canvas that doesn't belong there and I urge *you* not to put down a single stroke that hasn't been carefully observed, planned, and considered. One of the greatest appeals of the *premier coup* method is that it forces you to draw on all your mental, emotional, and physical resources and forces and to lay your artistic life on the line with every stroke by acting with deliberation, decisiveness, economy, and dispatch.

Principle 5: Discover the Larger Masses. Until now I've been urging you to make your every stroke count and practice economy of effort. However, never losing sight of this principle, certain limitations must be taken into consideration.

Unless you're Frans Hals, you won't be able to paint a finished head stroke by stroke without some preliminary, underlying steps. Those of us who are less than absolute masters must proceed to this goal in stages. Most of us, for instance, can't paint a finished eye right on the bare canvas. We must prepare some kind of base, a guideline upon which we can then proceed to lay in the final strokes. This forces us to view the head as a series of large masses over which such surface details as eyes and lips are then superimposed. If we don't paint the large mass of the head first, but just attack the eye, we might fall into the trap of getting the color of an iris "just so" without considering its correct placement within the socket.

Therefore:

1. Look at your subject as a series of large masses. After you've visually reduced the subject to three or four basic elements composed of light, halftone, and shadow, proceed to paint in these large masses over your preliminary drawing, using the biggest brushes at hand.

2. Once you've blocked in these large masses, paint in the smaller details that lie *within* or *upon* them. It can't be overemphasized, however, that even as you paint these subsquent details you must continue to cling to the concept of the head as *a series of large masses!* To see these masses as you work, you can shift from sharp to blurred focus by squinting slightly.

To illustrate: when you're painting in the eyes in the later stages, you should still maintain a mental picture of the dark mass of the sockets into which you then "drop the eyes like poached eggs into a plate," as Sargent put it. Thus, while you're painting the iris, cornea, and eyelids with accuracy, you're also remaining faithful to the larger mass that lies beneath and supports them.

This is thinking in large masses, which allows you to proceed in a natural sequence from broad, sweeping strokes to smaller, more precise strokes, while maintaining a vision or memory of the underlying structure. After all, you wouldn't fit in a windowpane before you've set up the beams, plastered the wall, and put up the window frame. Painting, like building, is merely working outward from the core, from the inside out, from foundation to floor to ceiling.

The rule is that if the basic large masses are correct, chances are that the features and surface details will fall into proper place as well. But the principle of working from big to small and from rough to refined is carried through only as far as necessary. When you've achieved your goal, stop even if the ear seems unfinished or the neck or hair lost in shadow. To go on is mere gimmickry and adds nothing either to the painting or to your luster as an artist.

Principle 6: Recover the Drawing. I recommend that you make the preliminary drawing with the brush, although these strokes are then completely covered in the ensuing process of laying in the larger masses. This often puzzles my students, who quite logically ask what purpose the drawing serves, since it becomes so quickly obliterated.

My answer to them and to you is: *Retain the mental image of this drawing in your mind*, just as you must remember the larger masses while painting the smaller details over them. *Refer to this image mentally as you proceed with the painting!* This demands concentration and alertness, which—you may recall—are two of the requisites of the *premier coup* method.

Keeping this drawing guideline firmly fixed in your mind tends to keep the painting fresh and in a constant state of renewal, since any deviation from the accurate contours and proportions are mentally measured both against the subject in front of you and against the fixed mental image. And corrections are made right on the spot, even if it means wiping out an area and repainting it all over again.

The alternative is to draw a very precise outline on the canvas and to paint strictly within these arbitrary borders. But this is a poor solution: you end up with a colored drawing rather than a painting.

To me, all painting is drawing, whether it's executed in line, tone, or color. Each time you make a calculated decision about where to place a stroke on the canvas, you're drawing. What's essential is that you assume a supercritical attitude toward your own efforts—and change a passage the *very moment you spot an error*. Never leave it for later; fix it *now*! This way, you'll remain alert throughout the session and not permit some beautifully brushed effect to remain just because it's "so gorgeous," even though you know that it's essentially inaccurate.

As you go on, always try to remember that what you should be doing is not painting, but *modeling the form*, which is the same as drawing. Be true to what you see before you, not to what you *think* you should be seeing. Retain the mental image of the drawing, and when an error appears wipe it out mercilessly!

Principle 7: Work with Speed. As a student, I once attended a painting class that lasted three hours, and subsequently I trained myself to complete the painting within that time period. Later, I took private lessons with the same teacher, but this time the sessions lasted only two hours. Naturally, I had to adapt myself to this new schedule; in a matter of weeks, I learned to complete the painting *within two hours*. Soon I began to ask myself what I had done during that third, unnecessary hour!

Time is precious and you must force yourself to paint as quickly as possible, making sure all the while not to lose one iota of quality or accuracy as you speed your efforts.

However, while speedy execution of a painting is always desirable,

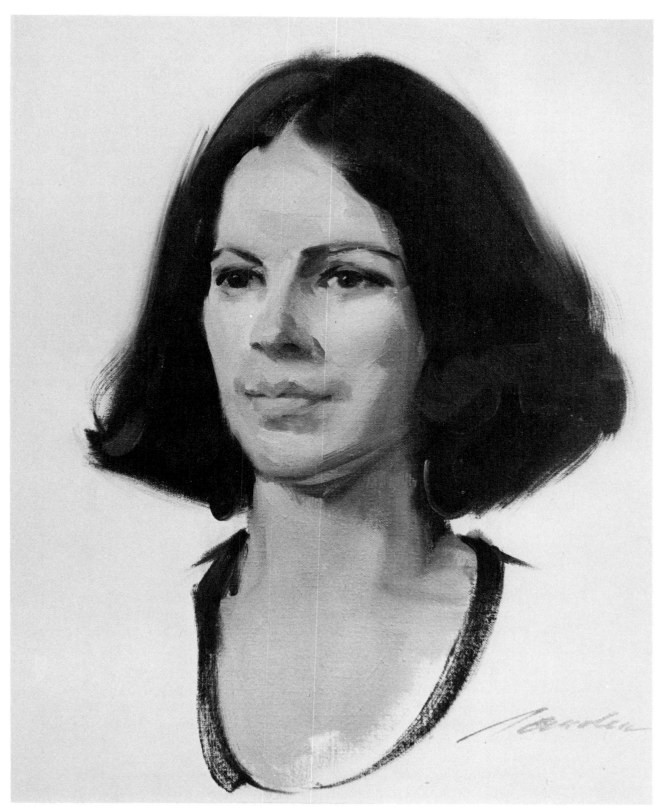

Head Study. *Oil on canvas, 24" x 20." This is a true vignette painting in which not even a trace of background appears. In all such instances you must keep two things in mind— not to allow yourself to be tricked into painting your highlights too light due to the all-white background, and to soften the edges of the head all around to avoid a hard, unreal appearance.*

you must never sacrifice quality for speed. "Get it right" is more important than "get it done."

Take the time to *make sure each step is correct before proceeding to the next, no matter how long this may take!* Don't go from painting masses to painting features until those masses are right.

Principle 8: Treat Your Edges Softly. In real life, most edges look soft. Since eyes are in constant motion, you see edges as soft unless you specifically *focus* on an edge, which then assumes a sharper contour. This principle should be applied to your painting.

Therefore, keep your edges soft unless: (1) you want to draw the eye to a particular area for compositional reasons or (2) you wish to make an area appear to advance.

A sharp edge or edges will fulfill both these goals. But an *excess* of hard edges in any painting is to be avoided, since they're the greatest enemy of the illusion of realism. However, a painting *totally* lacking sharp edges tends to be less attractive than one containing a few.

Remeber that next to a contrast of value or a color contrast, a hard edge is the *most powerful area of emphasis* you can attain in your painting—a means of drawing instant attention.

So, keep most of your edges soft, then strike in one or two hard edges in strategic places to add spice, tang, and interest to your painting. Always ask yourself: "Is the edge I'm seeing really hard or am I merely *assuming* that it's hard?"

Principle 9: Overcome the Fear of Failure. Timidity is the artist's worst enemy and boldness his most faithful ally. Never tiptoe about or sneak up on your painting, but attack it with all the daring, resoluteness, and decisiveness at your command. Even if you're quaking with self-doubt, try to boost your confidence before commencing a painting session, using any method that works best for you. Tell yourself that you must paint with assurance, with bravado, with complete disregard for the dark doubts that gnaw at the core of every human being.

Here are two methods to help this attitude along:

1. Squeeze more paint than you'll need onto your palette. Paint is relatively cheap and there's nothing more defeating than attempting a bold approach with tiny dewdrops of color, laid out daintily upon your palette. Lots of paint tends to help you work more richly, broadly, sweepingly, and daringly.

2. Avoid judging your rate of progress against others. Some people improve rapidly; some improve slowly; and some improve in stages—remaining at one level for years at a time, then moving ahead. There's no formula for artistic progress: it proceeds at its own pace. Some people even retrogress, going two steps forward and one back. Others leap ahead.

Whatever you do, don't gauge your own progress against anyone else's, for this can be a road to disappointment. Do all you can to improve, but let your rate of progress determine *itself*.

Over the years, I've noted certain patterns that govern the progress of art students. Those who approach their work with total ambition, with no timidity, with confidence, and with even a kind of arrogance—seem to attain their goal with greater frequency. The three traits that seem to count

most are: a burning desire; perseverance; and a healthy dissatisfaction with everything you've ever done before, coupled with the urge to do it better the next time.

Remember, a bold failure is better than a niggling semi-success. Take risks—it's the only way to achieve the *big* success. And once you do succeed boldly, this will prove a tremendous boost to your confidence. That one big success will hook you on painting for life.

A noted theologian, paraphrasing Descartes, said: "If you think, you will become." The power of positive thinking plays·an enormous part in the development of an artist.

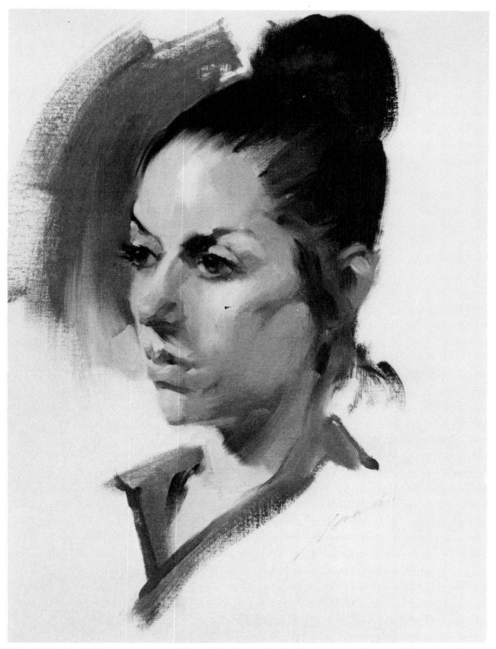

Head Study. *Oil on canvas, 18″ x 14″. One of the important factors in my painting method is establishing the mood of the portraits beforehand. In this instance it was one rather pensive. Note the bold but simple treatment of such elements as the mouth, nose, and jawline.*

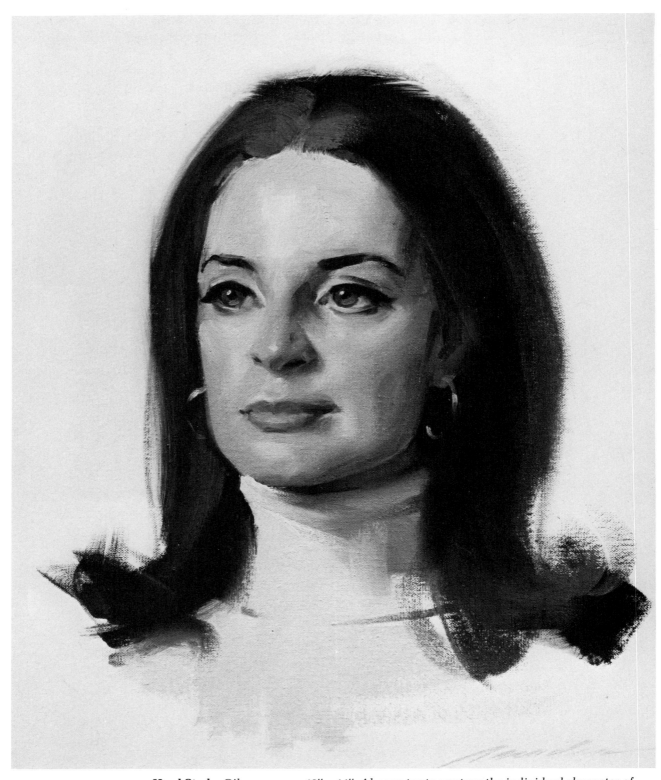

Head Study. *Oil on canvas, 18″ x 14″. Always try to capture the individual character of each feature of the head, otherwise you'll fall into the trap of painting stale, routine portraits. Note the sharp highlight on the tip of the nose, which is probably the most important brushstroke of all since it adds so much to the three-dimensional effect so desired in realistic painting.*

7. Painting the Upper Part of the Head

In painting the upper part of the head, consider the large, basic structure first: the solid form of the cranial mass rising above the facial mass and the bony formations that surround the eyes. Block in the broad planes of the forehead and treat the hair as if it were a solid form by giving it shadow, halftone, and light planes.

The eye sockets are protected above by the frontal bone and below by the zygomatic arch. The shaping of these forms is critical to the realism of the painting. The nose advances as a wedge-shaped object with a front plane, two sides planes, and an underplane. The primary task is to block in these basic forms—cranial mass, forehead planes, eye-socket formations, cheekbones, and nose-wedge. Try for a strong, simple statement of these forms before involving yourself with the smaller, more sophisticated details of the face.

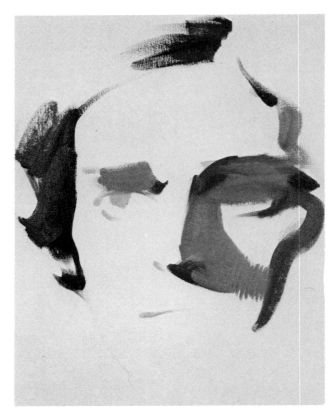

Step 1. In this beginning step my only purpose is to provide guidelines for the masses that will be painted later. This can be considered a kind of "map" that will establish the placement of the features as well as the distances lying between the various points of the head. This stage is intentionally kept to the barest minimum so as not to overwhelm or interfere with the painting steps that will follow. To place these beginning strokes I use a pale, neutral tone cut with turpentine to create a rather thin, loose wash.

Step 2. Now I establish all the shadows. First I use a really deep tone to place the darks around both sides of the face to fix its contours. I then paint in the shadow of the temple, right eyesocket, and the shadow side of the nose. I lighten this same tone a bit to paint in the model's left eyesocket. I darken the tone to place a few strategic shadows such as those in the corners of the eyes, under the nose, and under the right eye.

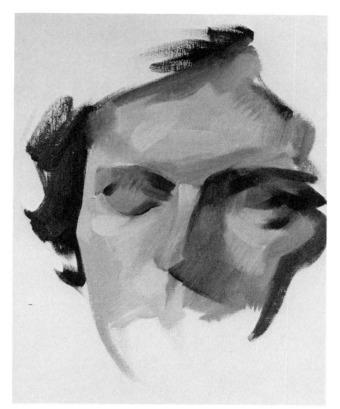 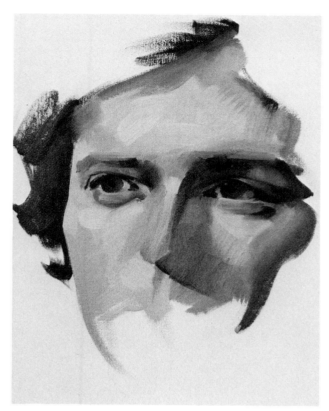

Step 3. Now I paint in all the halftones, starting on the shadow side of the face and working from dark to light in my usual manner. First I place the warm halftone that falls between the shadow and light sides of the sitter's right cheekbone, then I use the same mixture, somewhat lightened, to paint the corresponding plane on the left (light) side. I place the halftones on the plane falling between the right temple and the forehead, then repeat the procedure on the left side. Next comes the halftone covering the nose and on the ridge of the brow between the eyebrows. I place the halftone just under the hairline and the halftone running from the side of the nose into the cheek. At the same time I modify somewhat the deep tone of the cast shadow under the nose. Now I paint the corresponding nose-into-cheek halftone on the light side, again using a somewhat lighter tone. I paint both eyesockets with lighter and darker halftones, attempting to gain a general tone and shape without going into detail of color or separating the various components of the eye. Now I begin to place the lights—first under each eye, then on the bridge of the nose, on the upper lip, the two lights that compose the frontal plane of the forehead, and the reflected light on the left temple just where the light and halftone meet.

Step 4. Now I'm ready to commence some detail work. First I rub my thumb lightly over each eyesocket to remove the excess paint that has accumulated there and to provide a smooth surface on which to paint the various parts of the eyes. I place each iris in position, then use a dark tone to paint in the top of each lid, the corners of the eye, and the edges of the lower lids. I then paint the line where the fold of the upper lid meets the eyesocket just below the brows. I lighten the areas of the so-called "whites" of the eyes. Remember, they are never white! Now I place the pupils. I paint the brows in three strokes each, keeping them simple but distinct in shape.

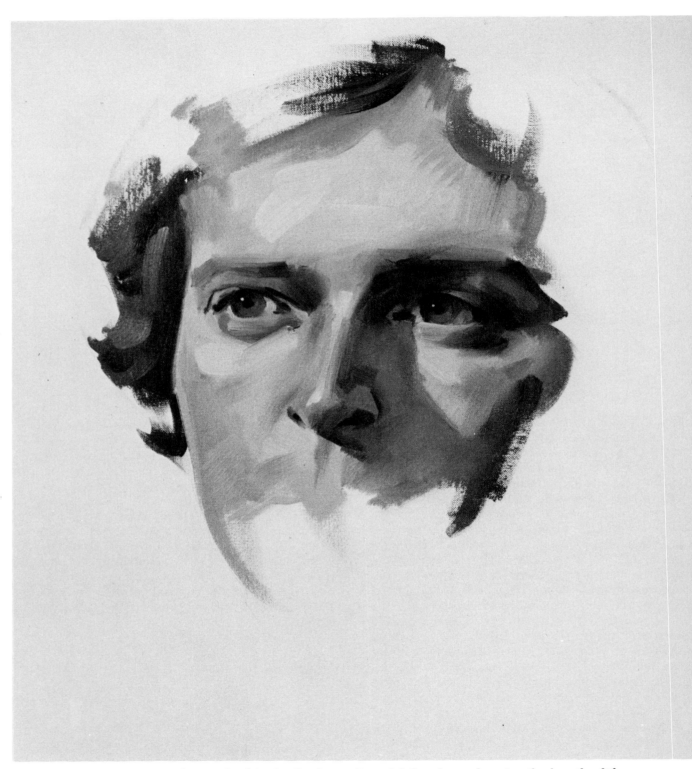

Step 5. In this, the final step, I model the planes forming the length of the nose and shape its tip. I put in the dark of the nostrils and the shadows that form at the fold between the wing of the nostril and the cheek. I place the all-important highlight on the tip of the nose. I unify the shadows at the outer corner of the left eye. I restate the hair and the shadow of the face to give a more accurate and forceful contour to the shape of the face and darken the halftones somewhat on the cheekbones to strengthen the tonal range of the head and help model the form. And finally, I place the catchlights in the eyes.

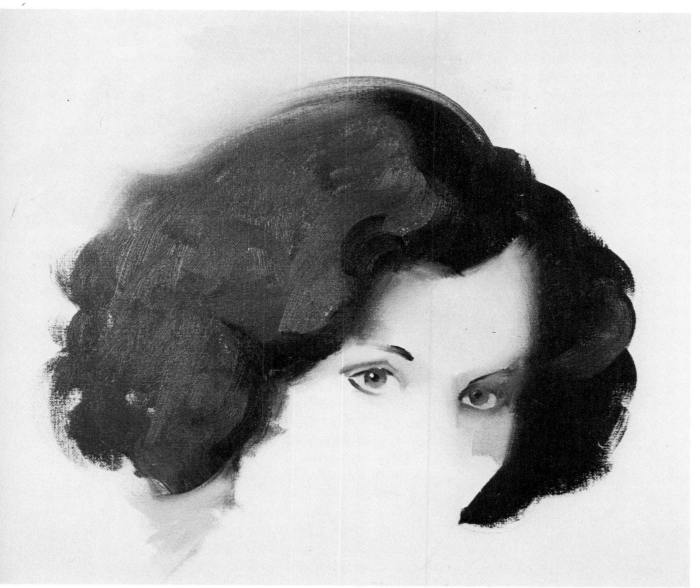

Step 1. First I mix an exact tone for the darks of the hair and paint them in, then I mix another for the lighter side and paint *it* in so that the entire mass of hair is covered.

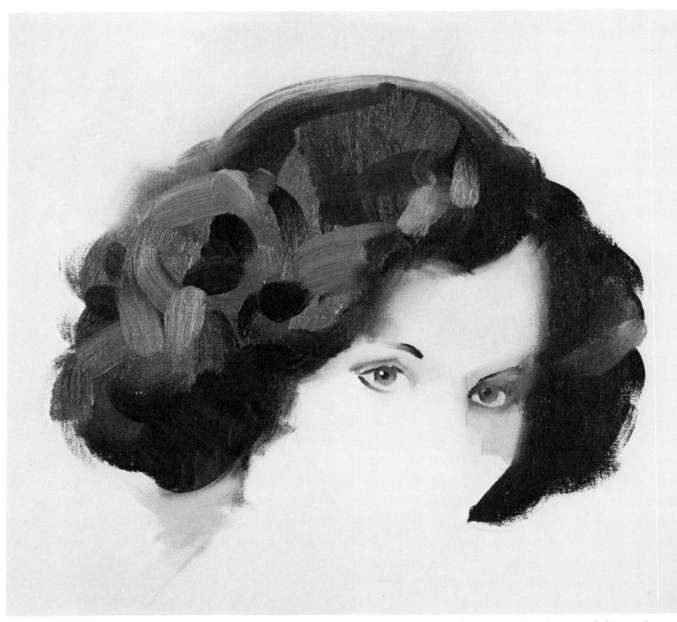

Step 2. Since this model's hair is rather curly, I paint in the shapes of the curls, handling them simply in three tones of shadows, halftones, and lights. I then soften the edges where the hair fades into the face and background, making sure, however, that I don't sacrifice its form in the process. I also indicate the various lights as they appear on the curls.

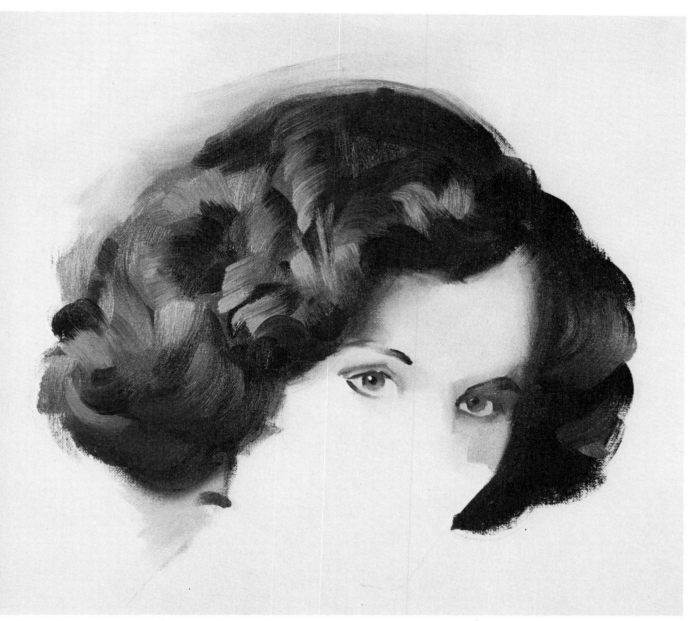

Step 3. In this final step I run my fan brush lightly over certain areas to achieve a blended effect and also to attain texture. I also use my regular brush to draw and structure the shapes of the hair as it flows and curls in various directions. One has to be careful not to overdo when painting hair, since in the effort to obtain a more realistic texture one is liable to sacrifice the feeling of solidity hair must express. In those places where there is a painted background, I drift the two areas together. In the areas between hair and bare canvas, I use a dry brush to "lose" the edges of the hair.

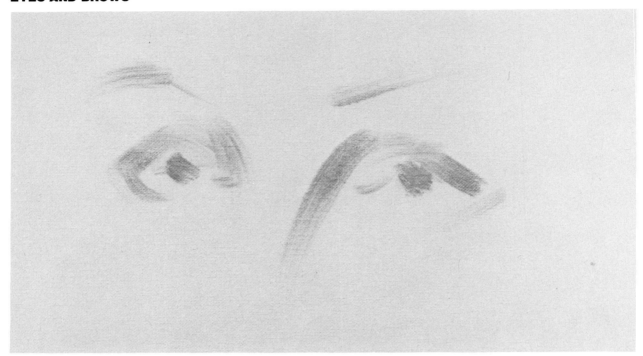

Step 1. With a pale neutral gray I indicate the pupils, the eyelids, the brows, and the shadow on the nose.

Step 2. I now place some darkest shadows to indicate what form the eyes will take.

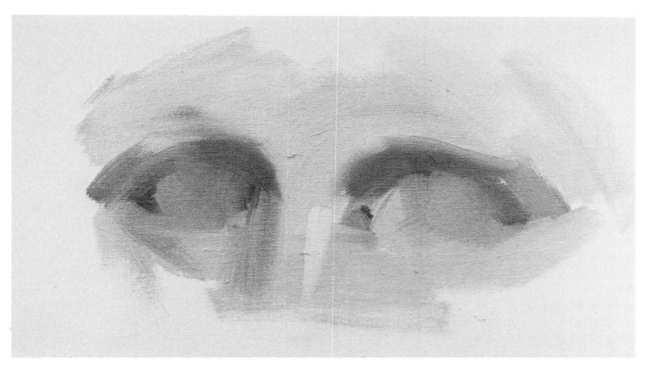

Step 3. In this step I fill in the eyesockets with halftones, shaping the eyes and establishing their relationship to the nose and other areas. Although in doing this I lose some of the guidelines, I have mentally recorded them and will draw on these memories in the subsequent steps.

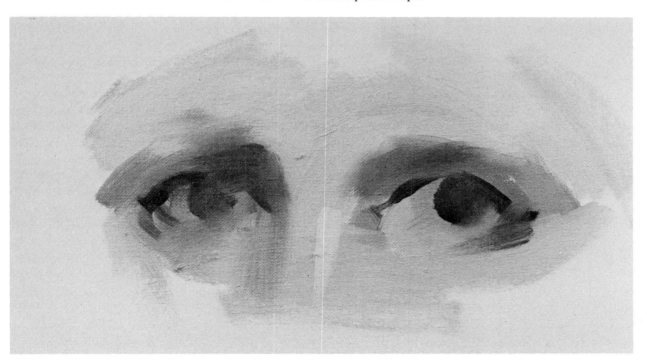

Step 4. I remove some of the excess paint from the eyes so that I can work into the area without fear of the colors being diluted by the underlying layers of paint. First I paint in the color of the irises. Then I shape the edge of the upper lids from the outside corner inward and from the inside corner upward and toward the center. I paint part of the edge of the lower lids, indicating the crease of the bag where it appears under the left eye. I then restate the left eyesocket somewhat more precisely.

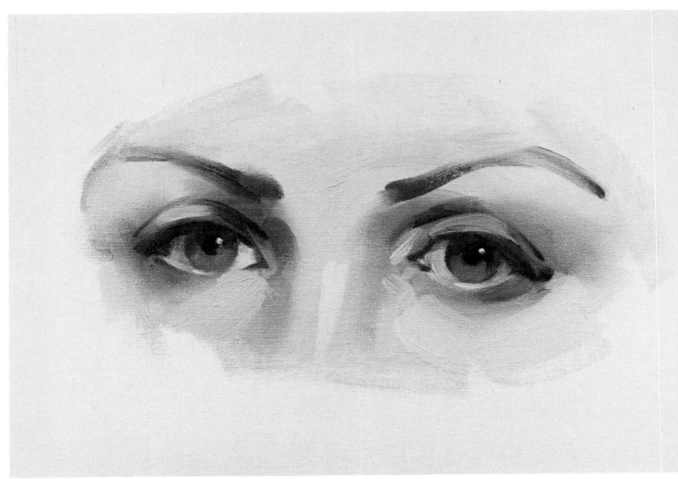

Step 5. I indicate the four areas inside and outside of the iris, where the whites of the eye occur. As you'll note, each of these four areas is of a different value. Never paint the whites of the eyes as pure white or *automatically* in the same value unless they happen to actually be so. I now paint the various *tones* of the iris. As you can see, the upper part is darker due to the shadow cast over it by the upper lid. Then I place the black of the pupils and put some reflected lights in the iris. Next I paint the brows as directly and boldly as possible, in three strokes: from the inside to the center, from the outside to the center, the final middle stroke. I shape the upper and lower lids and paint the lights falling on the rims of the lower lids. I place whatever highlights occur on these rims. I paint the pink membrane in the inside corners of the eye. I place the highlights in the corners where the eye meets the bridge of the nose. I put in the catchlights at the edge where the pupil runs into the iris (never inside the pupil itself).

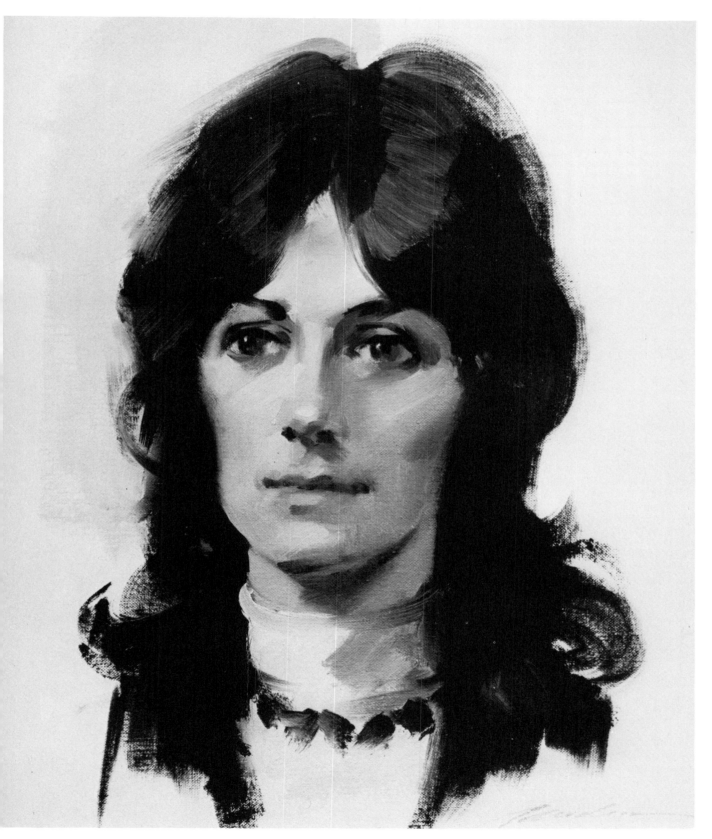

Head Study. *Oil on canvas, 18″ x 14″. This model's rather deepset eyes are painted with lots of strong shadows surrounding them to lend the effect of depth. Note the position of the catchlights in the eyes which are never painted inside the pupils but at the juncture between pupil and iris to avoid a glassy, unreal appearance.*

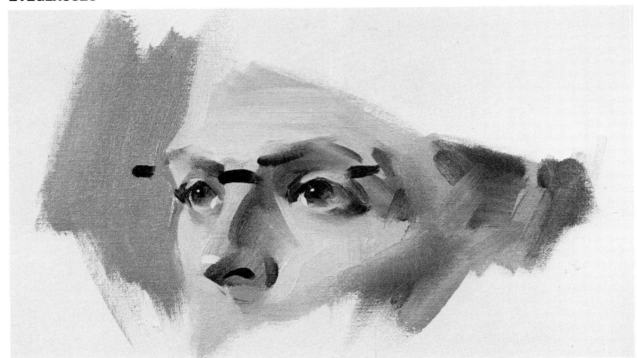

Step 1. Painting eyeglasses is really a problem in perspective rather than form. Always have your sitter remove his eyeglasses then don them again once you have completed painting his eyes. I make three finished strokes to mark the three top horizontals formed by the frames.

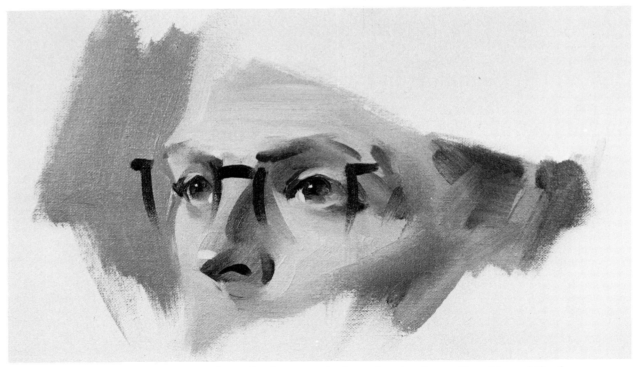

Step 2. I place the four vertical strokes to shape the sides of the lenses.

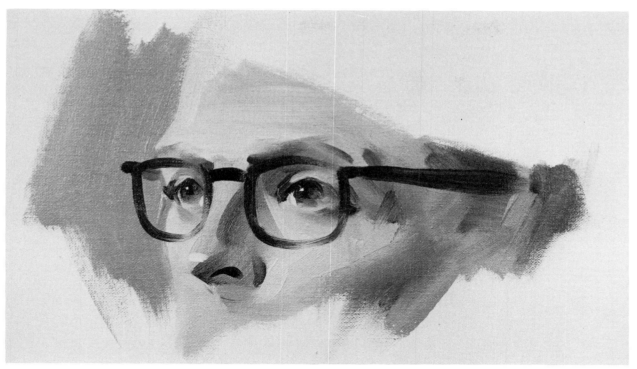

Step 3. I paint in the rounded tops and bottoms of the lenses and the stem of the frame, completing its shape.

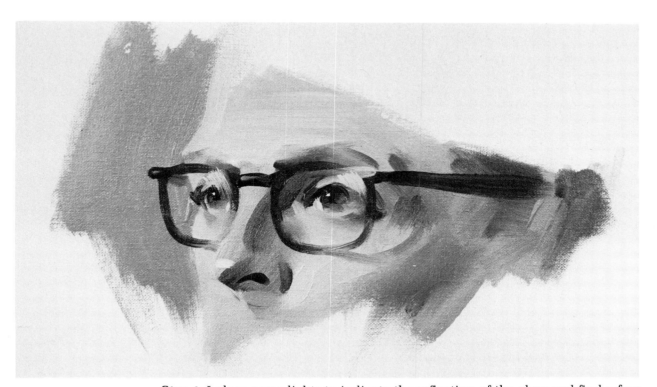

Step 4. I place some lights to indicate the reflection of the glass and find a few highlights on the frame itself. Never paint the lenses in such a way as to show their thickness or the manner in which they distort the eyes or the contour of the face.

Bill Hayes. *Oil on canvas, 30″ x 24″. A combination of eyeglasses and beard might tempt one to allow these two outstanding factors to dominate the portrait. Never let a single feature overwhelm the painting to the detriment of the total effect. Note how the stem of the eyeglasses was painted in a single decisive stroke. Whenever possible, use the absolute minimum of brushstrokes to gain the desired effect.*

Head Study. *Oil on canvas, 18″ x 14″. The hair is highlighted with crisp, sharp accents that point up its individual texture and character. The glasses are treated distinctly yet no effort has been made to show the glass of the lenses, which would tend to distort the areas lying behind them.*

Step 1. I establish the length and the placement of the nose by indicating the nostrils and the direction from which the light is falling. A most important factor in this step is to show the line where the dark of the nose meets the light.

Step 2. I paint in the shadows and the darkest accents.

Step 3. This is the vital modeling stage. First, I establish the tones on each side of the nose, then divide the area beneath it on the upper lip into light and dark in order to give substance to the tip of the nose lying above it. Next, I completely cover the frontal plane of the nose and the halftone running from the nose into the cheek on the light side. I now model the tip of the nose from dark to light and place the nostrils. I paint the shadow cast by the nose and finish shaping the wing of the nose on the light side.

Step 4. In this step I blend the tones on the nose to obtain an effect of roundness, then place the highlight on the tip in one stroke. If it emerges too thick or too big, it's better to remove it than to try and fix it, then take another stab at placing it correctly in a single stroke. I consider this the most important stroke in the painting since it serves to make the nose seem to advance and lends the effect of reality to the painted head.

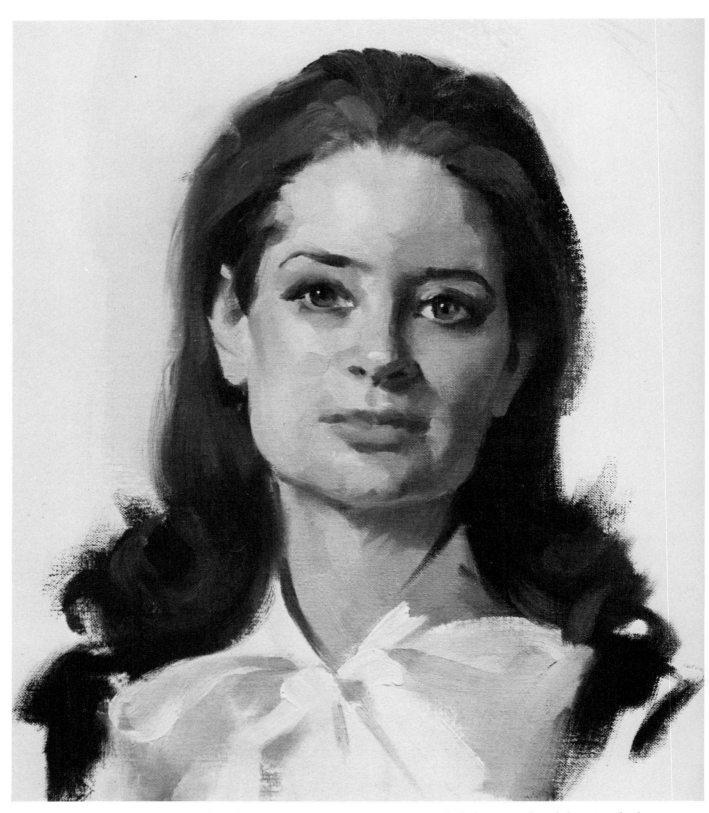

Head Study. *Oil on canvas, 18″ x 14″. Strong side-lighting produced the crisp shadows in the sitter's head and allowed for a full range of value gradations in the portrait. The only reflected light here is that thrown back into the model's left chin and jawline by the white blouse she is wearing. The head is modeled firmly and the edges are slightly crisper than in some of the softer portraits. I believe the full frontal view was most effective in portraying this sitter's open, straightforward personality.*

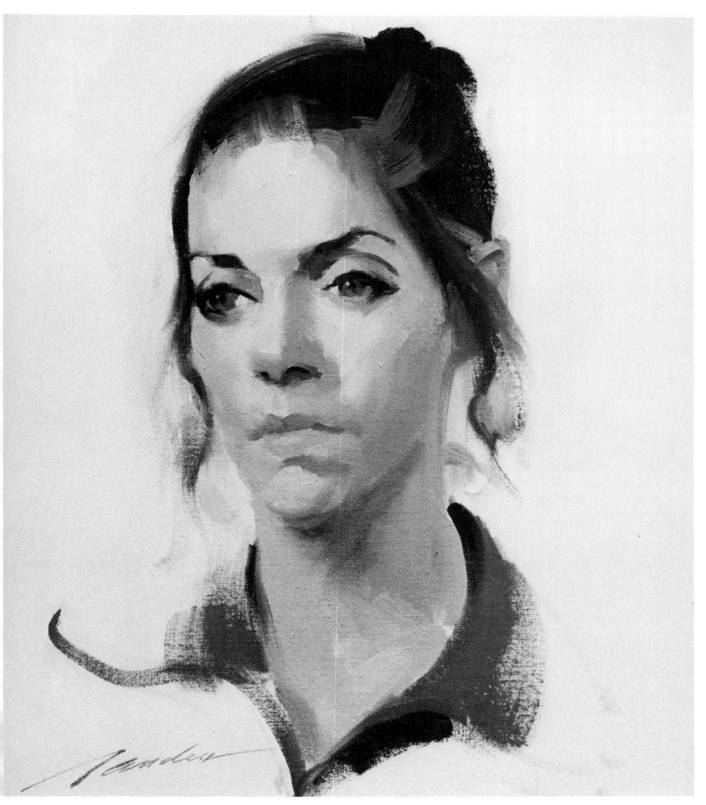

Deanna. *Oil on canvas, 18" x 15." To learn to see in angles, you must look for such repeated directional thrusts as the diagonal halftone upsweep in the hair, the cock of the left eyebrow, the line separating light and shadow on Deanna's left cheek, the angle of her jawline, and finally, that of the shirt collar. Such observation is most helpful in drawing the head for the portrait.*

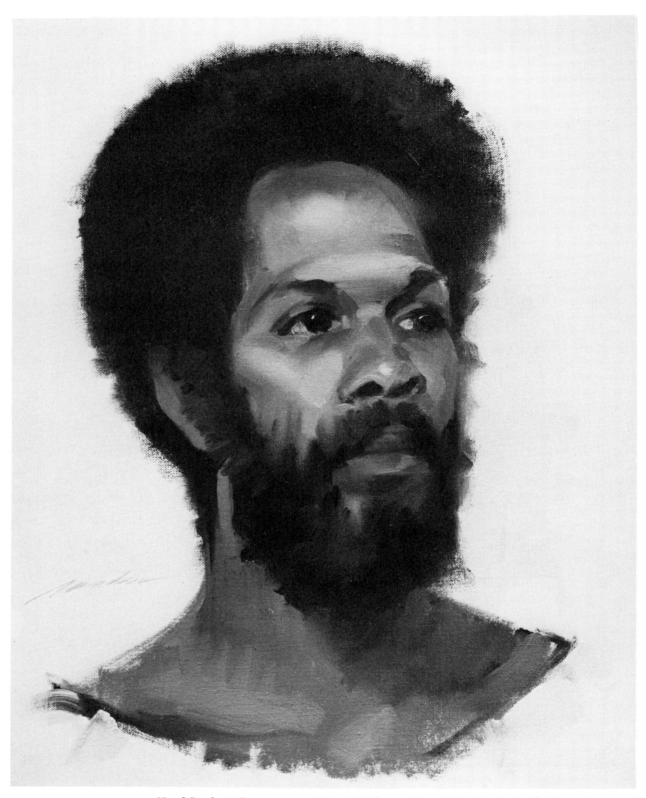

Head Study. *Oil on canvas, 18" x 14". Observe how I tried to depict the fuzzy texture of the model's beard. Also note the casual treatment of the ear which should—in all instances—be recorded very simply and unobtrusively.*

8. Painting the Lower Part of the Head

The lower part of the head comprises the jaw, the mouth, the chin, and the throat. The first priority must be given, as always, to drawing: achieving a strong, simplified grasp of the character of the bony structure of the jaw. Try to see the jawline (even in a fleshy face) in terms of angles and straight lines—this will give you a better chance to state its essential character than by copying its many details and curves. Then paint the planes of the mouth area to achieve the fullness and forward thrust of the dental arches. The retiring halftone planes around the mouth—*surely the most difficult part of the entire portrait*—are next. When the mouth itself is rendered, it should be thought of only as the *climax* of the lower face. It takes the entire lower face to make a mouth. Soften the edges of the lips and strive to show how the mouth forms flow out of, and into, the elementary facial forms. Then state the highlights and halftones of the chin, place a strong shadow under the chin, and indicate the reflected light that usually illuminates the underside of the chin and jaw. The throat should normally be stated as simply as possible; strive for the effect of a vertical column in light and shade, rather than an anatomical study of muscles and cords.

Step 1. With a thinned, neutral tone I indicate the things that matter in this preliminary, mapping stage: the right contour of the face where the flesh meets the hairline; several strokes to roughly show the hair; the most important line separating the light from the shadow; the outer contours of the neck; the bottom of the nose; the division of the lips, bottom of the lower lip, and the corners of the mouth; the bottom of the chin and the shadows cast by the nose and chin.

Step 2. I now proceed to paint in all the shadows on the face in a tone graded 7 on our value scale. I then use a tone darker to show the hair on either side.

Step 3. I cover the entire area first with halftones then with lights. I paint the protuberance of the mouth, sometimes called the "barrel," first on the right, or shadow, side, then on the left. Then I paint the series of halftones running from the cheekbones to the nose; then the lips and chin, first on the shadow side then on the corresponding light side, and finally I correct the halftones comprising the chin. I brush some halftones into the dark of the neck, softening the shadow there somewhat, and follow this by covering the light side of the neck completely. I proceed to darken the shadow cast by the nose, then move on to the lights. First I put in the lights on the frontal plane of each cheek, then I place the highlight on the chin. I then paint in all the reflected light falling on the edge of the right jawbone, on the neck, and below the chin.

Step 4. First I remove the excess paint from the mouth area with my thumb then lay in a dark tone for the upper lip in three strokes: side, center, other side. I then mix a lighter shade for the lower lip and place it in a single stroke. I paint in the corners of the mouth in darker tones and run a dividing line between the lips, again employing the three-stroke method: side, center, other side. To complete the step, I paint the dark stroke beneath the lower lip.

Step 5. In the final stage I work carefully to place the halftones running up slightly from the corners of the mouth. These are very subtle planes and must be painted with extreme deliberation so that they emerge just so—neither overstated nor understated. I now proceed to shape the chin in order to show its cleft. I soften the edge of the shadow cast under the chin and blend it into the adjoining halftone. I darken the area above the upper lip, redraw the center of this lip, and go down to model the dark area lying just under the lower lip. I then place the highlight upon the lower lip itself. I travel upward again to restate the groove lying above the upper lip and place the appropriate highlight there. I indicate the line that runs from the left nose wing to the left corner of the mouth. I place the highlight above the left upper lip and the reflected light that falls just below the corners of the mouth. Finally, I place the highlight on the Adam's apple.

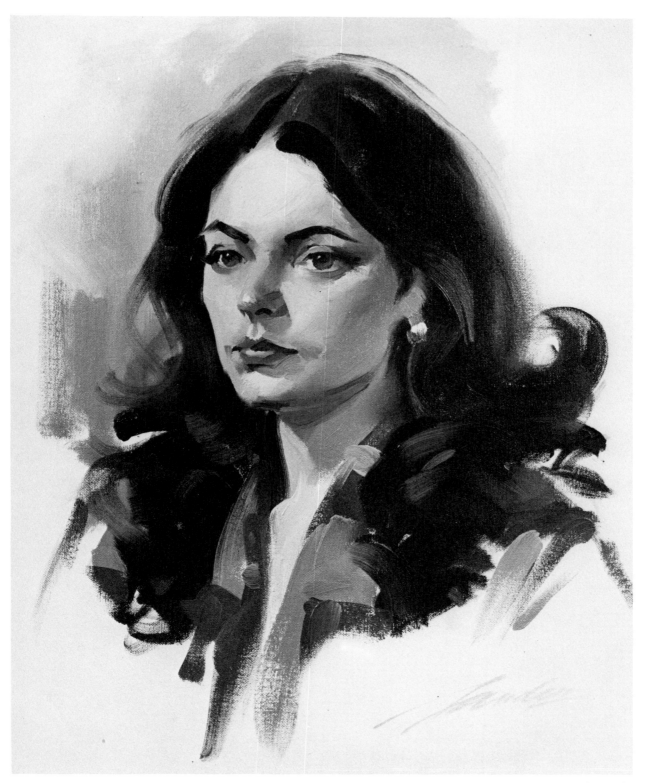

Patty Palermo. Oil on canvas, 24″ x 20″. Rendering the effect of light as it falls on the complex planes around the mouth is surely one of the most difficult assignments in painting the head. These planes are just as essential to the expressiveness of the mouth as the lips themselves. With Halftone 1 (darkened somewhat) I painted the depressed areas at each corner of the mouth, and rendered the area above the mouth in three planes—two sides planes and a central plane which carries the groove down from the nose. The side planes are greenish gray and the central plane is highlighted. A cast shadow below the lower lip and a strong highlight on the chin give form to this area.

Step 1. The ear, with all its dips and convolutions, is a rather strangely shaped object. I suggest that you paint it as simply as possible, avoiding overstatement since it serves no purpose whatsoever to show more of the ear than is absolutely necessary. First, with a series of lines showing the general direction, I indicate the general silhouette of the ear: the top; then the bottom; then the vertical line in back and the curving underside of the lobe; then the inside void, or concha, as it is known.

Step 2. I put in all the shadows cast by the major forms.

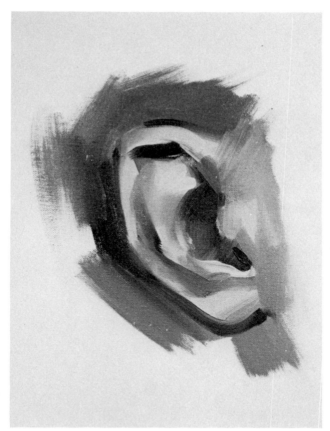 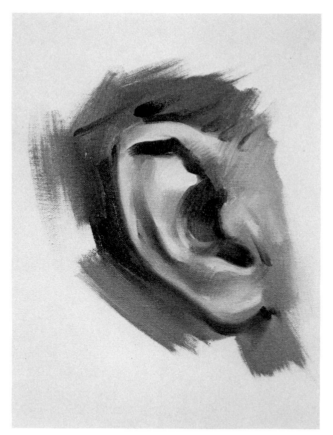

Step 3. I cover the entire ear with halftones, working from dark to light and leaving the light areas for last. I try to indicate this in the biggest forms possible and by showing the general shapes of the ear without going into meticulous detail. I make sure to indicate those places where the ear joins the face or temple so that the ear emerges as part of the head rather than as some separate entity.

Step 4. I proceed to soften edges in all but a few areas (such as where it folds sharply in just under the top) and to mute the planes so that they seem to naturally flow into one another. This is accomplished by uniting the planes without at the same time losing their essential form or values.

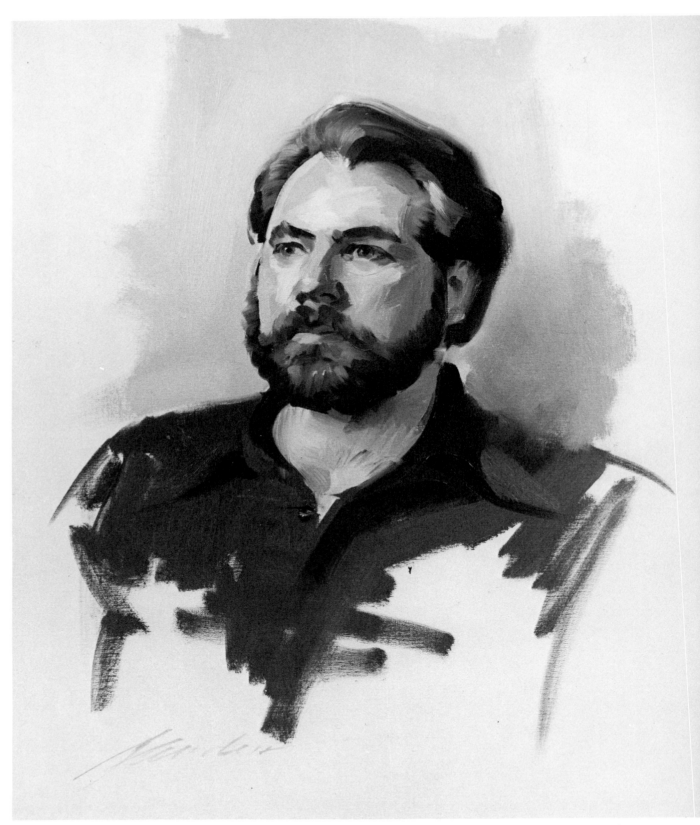

Patrick Hockenberry. *Oil on canvas, 30″ x 24″. In this instance, the mouth and chin area is completely bearded. The beard is separated into distinctly distinguishable lights, halftones and shadows. Hair, whether on the head or the chin, should never be painted as an entity but always as an extension of the skin areas. Above all, never fuss with hair but paint it loosely and simply.*

Step 1. A few strokes made in a neutral tone show the placement and shape of the lips.

Step 2. Dark shadows are placed beneath the lower lip and on the shadow side of the corner of the mouth. Several lighter tones indicate areas adjoining the lips.

Step 3. The mouth is completely covered with halftone with a memory retained of the shape it presents.

Step 4. Excess paint is removed with the thumb. A tone is mixed for the upper lip, which is then painted in, first the dark then the light areas. A tone is mixed for the shadow part of the lower lip and then one for the lighter parts. The corners of the lips are stated in darks and a stroke put in to separate the lips.

Step 5. The tones are blended on the upper lip and its edges are softened as it meets the skin of the face. The highlight on the lower lip and the reflected light at its very bottom edge are placed. Several additional dark and light tones are used to model the lower lip and help achieve the effect of roundness.

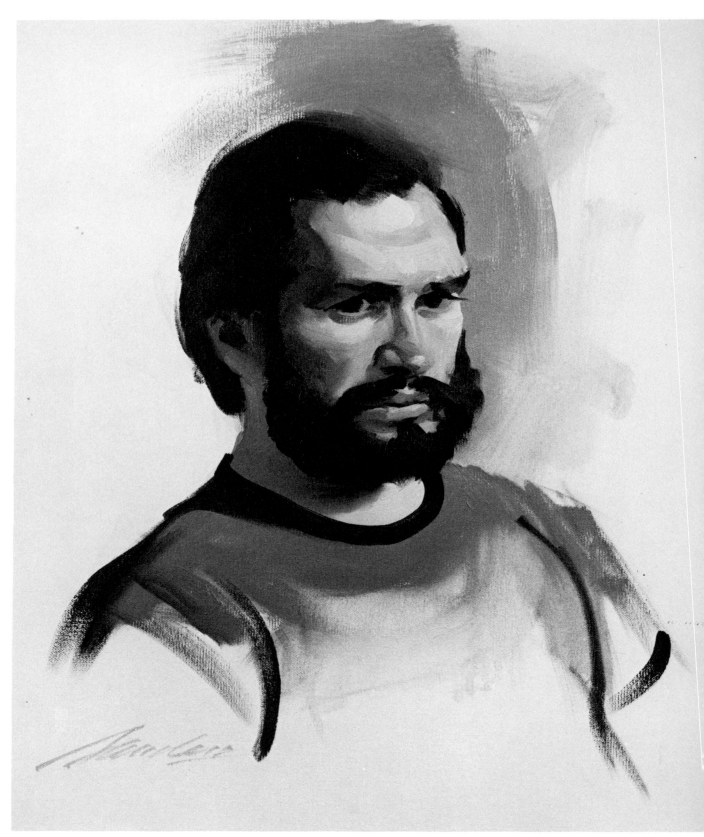

Study of a Man. *Oil on canvas, 24″ x 20″. Note how significant is the dark slash separating the lips! Cover this line with your finger and see how much character is lost from the expression. No wonder artists through the ages have agonized about the trouble of getting the mouth just so!*

Smiling Mouth. Paint the teeth as a mass, without running lines to indicate individual teeth. However, you can place a light here and there to hint at such divisions. Never paint teeth as white as you might see them in a toothpaste ad; look for the actual value they present, which will always be degrees darker than white.

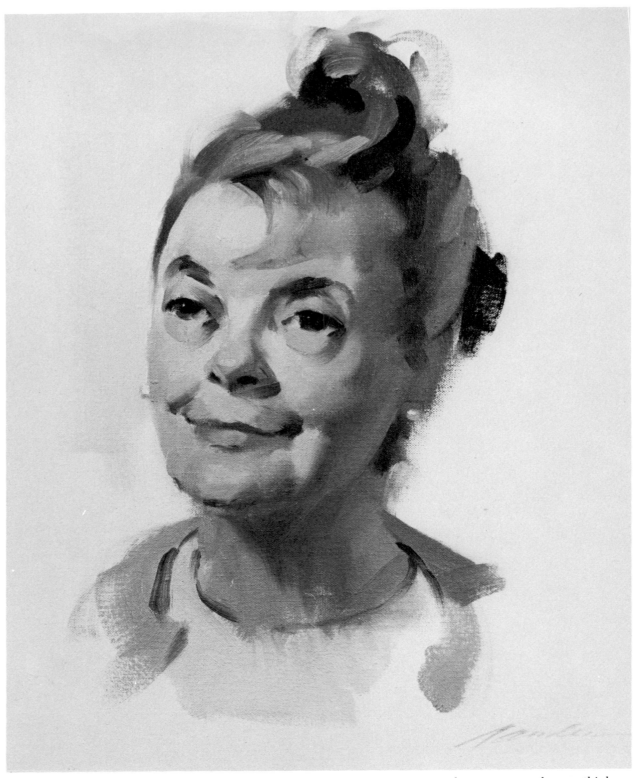

Head Study. *Oil on canvas, 18″ x 14″. Contrary to what many people may think, we smile not only with our mouths but with our entire faces. Cover the lady's mouth with your hand. Isn't she still smiling? This is a valuable reminder of the close relationship that exists among all the features of the head, all of which are closely dependent upon and supportive of one another.*

Frank Willbright. *Oil on canvas, 24" x 20". Frank is well known to all illustrators. He has been the genial barman at the Society of Illustrators for over thirty years. I couldn't resist the temptation to paint him with a broad smile because that is how we all picture him. He sat for me in the studio on the top floor of the Society's New York clubhouse. (Collection Mr. Frank Willbright)*

Mrs. James M. Barnett. *Oil on canvas, 48″ x 38″, Mrs. Barnett was in her eighties when she sat for this portrait—a gracious, beautiful, regal lady. She grew roses at her Albany, Georgia, home where this was painted, and so I included a bouquet. Her dress was black, but I changed the color to a deep wine red. (Collection Mr. James Barnett)*

9. Planning and Composing Your Portrait

There is actually no such thing as a portrait painter, there is only the painter who happens to be painting portraits—or more accurately, heads.

Painting, all painting, represents an attempt to show the effect of light falling on form. In the case of "portrait" painting this form is the head, shoulders, etc. The painter's attitude, therefore, must be to constantly remind himself that he is concentrating on reproducing the effect of this illumination by breaking it up into lights, halftones, shadows, highlights, cast shadows, and reflected lights.

Painting the head encompasses no sophisticated refinements that apply exclusively to the portrait. It's merely a straightforward exercise in painting that once learned and acquired can be successfully repeated again and again no matter who the subject may be.

However, in planning the painting of the head, several important practical decisions must be formulated prior to commencing the actual painting. Let's consider these one at a time.

SIZE My experience has been that it's best to paint the head in actual lifesize for two reasons: (1) this presents a most realistic appearance, and (2) it makes it easier for the painter to execute since it lends itself most comfortably and naturally to the artist's eye and hand.

The second best choice is to paint the head smaller than lifesize. The third and worst choice is to paint it bigger than life. I don't like this latter approach at all since the effect it produces is often distorted, unreal, and freakish.

I've found that an 18" x 14" canvas is best for the painting of the head alone plus the mere suggestion of the neck. For the head and most of the shoulders, 20" x 16" is best. For the head, shoulders, and down to the middle of the upper torso, 24" x 20" is best. And for the figure up to the waist, with the possible inclusion of a hand or hands, 30" x 24" is best.

All these sizes are height x width, representing vertical canvases.

THE SPIRIT OF THE PAINTING This phase of the planning deals with such considerations as determining the key of the painting. Will it be in high key (generally light in value) or in low key (generally dark in value)?

Also, will it be painted in vignette form (a rough, informal shape with some of the white of the canvas showing) or painted fully to the edges?

Also, will the effect be formal or informal? Serious or gay? What expression will the subject's face register—stern, laughing, pensive?

The Melvin L. Wiesenthal Family. *Oil on canvas, 50" x 70." This handsome family posed for me on the lawn of their suburban home. It was very cold and we worked fast, as they sat on a rock formation. Then we came indoors, and sofas and a piano bench were piled with books and pillows to simulate the rock formation. Later, each member of the family came to my studio in New York for sittings—except Romeo and Juliet, the poodles, who stayed home. (Collection Mr. and Mrs. Melvin Wiesenthal)*

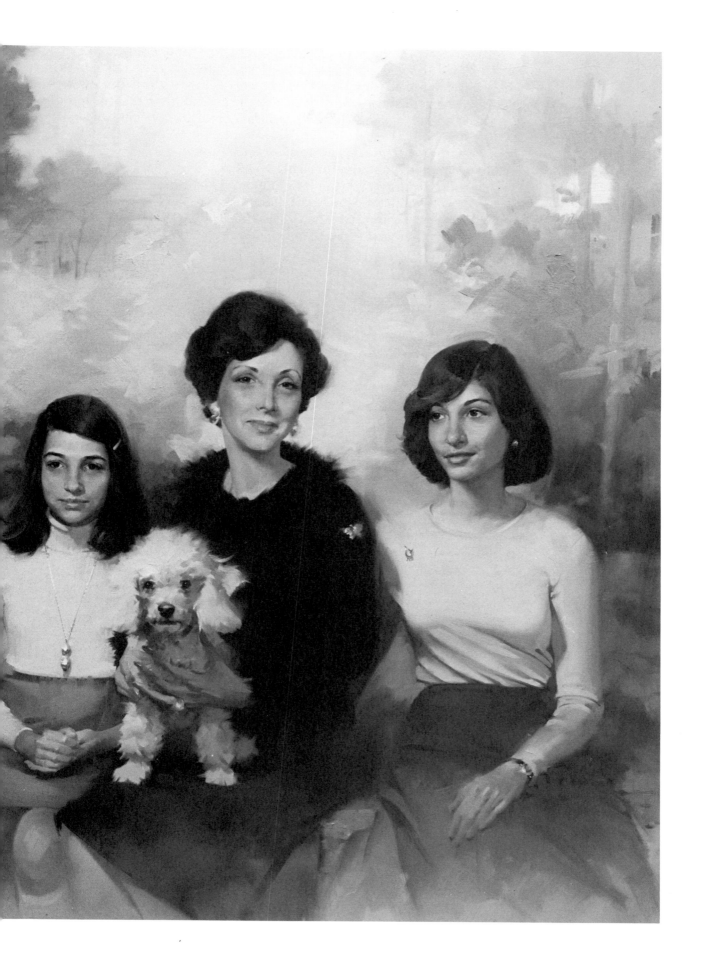

Since these combinations of key, mood, shape and emotion are infinite, it's best to establish both in your mind and in your model's just where it is you are heading, and having arrived at these decisions, to stick to them firmly. If things seem not to be working out to your satisfaction, *don't alter these decisions but discard the canvas and begin anew!*

THE SUBJECT'S DRESS
Having determined the size and spirit of the painting, let's turn to another consideration. How should your sitter be dressed?

Since we're dealing with the painting of heads in this book, our concern is basically with the upper part of the subject's garments—those covering the neck and shoulders. These areas can play a vital role in the final result and they do require your careful attention in the planning stages of the portrait.

If you're painting a noncommissioned portrait you can select some exotic, picturesque costume for your model as an interesting departure from the sober, conservative clothes you might encounter in your commissioned work.

Hats lend spice to a head study and offer an opportunity to arrange some fascinating shadow effects on the face.

It's fun to paint all kinds of hats or to dress your model up in some exotic costume for an unusual effect. However, whatever kind of clothes your subject will ultimately pose in, you should determine beforehand whether the garment that will best suit you should be basically light or dark in value, formal or casual, plain or patterned.

Don't stay away from patterned clothes since they, too, can add tang to the picture if given a playful, carefree treatment. But don't attempt a precise, meticulous study of such a garment; suggest its essential character with a few bold strokes.

It's also very challenging to paint various textures of material, trying with your brush to indicate the inherent qualities of wool, cotton, silk, fur, etc.

Apart from their picturesque aspect, the key guiding the selection of garments is their *appropriateness.* If you're doing a commissioned portrait you may want to discuss the question of costume with your subject when planning the picture. Urge him to select some favorite garment that his friends and relatives associate with him particularly.

A final consideration and one that relates to the design of the portrait is the character of the neckline of your sitter's garment. Particularly in the case of women's clothes there is the choice of a high, low, square, round, scoop, U or V neckline, each of which will produce a different effect. Consider this aspect carefully particularly in the head-only study.

THE POSE
It's time now to analyze your subject's face. Imagine that you've been asked to describe him to someone who has no way of actually seeing him and depends upon you for a most accurate description.

Consider your subject both feature by feature as well as in total view, both in the physical aspect and the emotional.

For instance: What's the general shape of his head—round, square, narrow? What about his eyes, his nose, his mouth, his complexion, his general proportions, the attitude he projects?

Having analyzed, digested, and weighed these factors, experiment with a few poses. Try him facing front, ¾ to the left, ¾ to the right, in left and right profile.

Dr. Michael E. De Bakey. *Oil on canvas, 24" x 16". I was honored to paint the distinguished American surgeon who was the first to employ an artificial heart during a complex heart operation. The treatment here is particularly loose and fluid. The eyeglasses were painted in last, after the features underneath had been completely articulated. (Courtesy the Reader's Digest Association)*

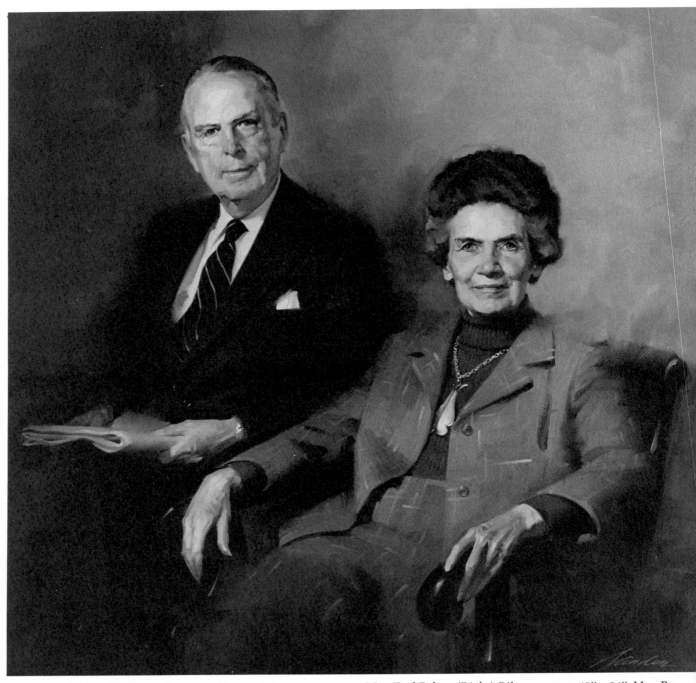

Mr. and Mrs. Phillip L. Corson. *(Above) Oil on canvas, 42" x 42". This portrait hangs in the administration building of Ursinus College near Philadelphia. Mr. and Mrs. Corson sat for me in their beautiful home in Plymouth Meeting, Pennsylvania. Both were strong personalities, and it was a challenge to compose a double portrait that would balance properly. I think that the figures should flow into and out of the background, and you will see many instances of this here—for example, where Mrs. Corson's shoulder meets the background, or where Mr. Corson's arm beyond the newspaper merges into the dark beyond it. (Collection Urisnus College)*

Mrs. Erol Beker. *(Right) Oil on canvas, 40" x 34". Mrs. Beker was so attractive in her white dress that every way I posed her looked perfect. It was so difficult to decide on the pose that I ended up painting two finished portraits of her. The other version is reproduced on page 129. This pose expressed her grace and poise, and the furniture and bouquet suggested the gracious style of her Fifth Avenue duplex. (Collection Mr. and Mrs. Erol Beker)*

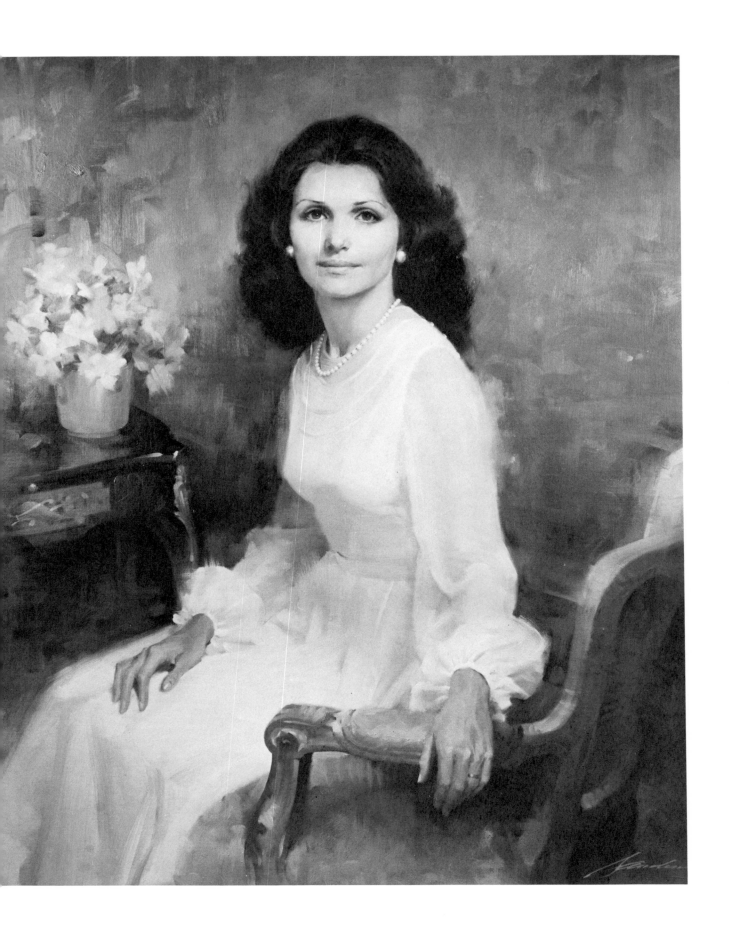

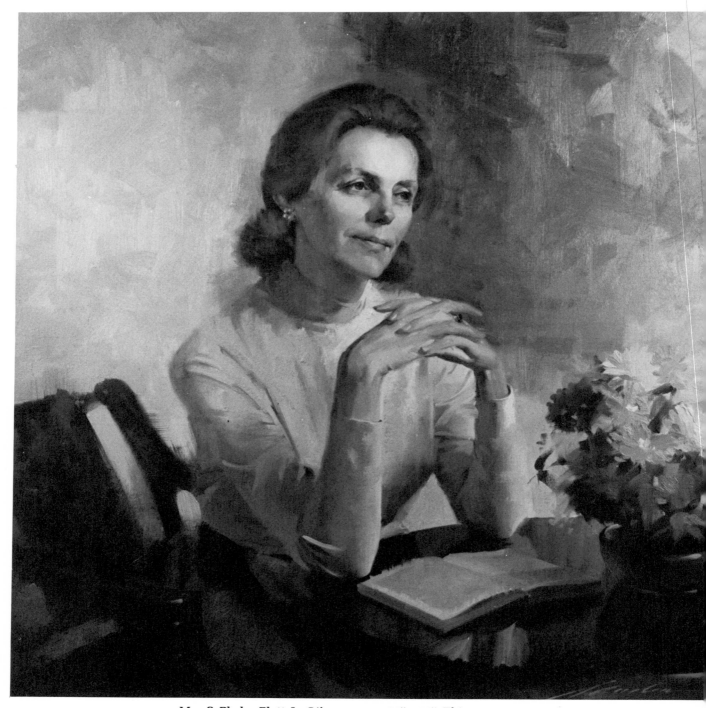

Mrs. S. Phelps Platt, Jr. *Oil on canvas, 31" x 29". This was an attempt to create a compo-sition somewhat different from the customary "head-on" portrait. Mrs. Platt's husband is a publisher and their New York apartment is filled with books. We decided to include a book and to use a reflective pose. Mrs. Platt's hands are expressive and I wanted to feature them. The blouse is pale cerulean blue and the skirt is dark blue checks. (Collec-tion Mr. and Mrs. S. Phelps Platt, Jr.)*

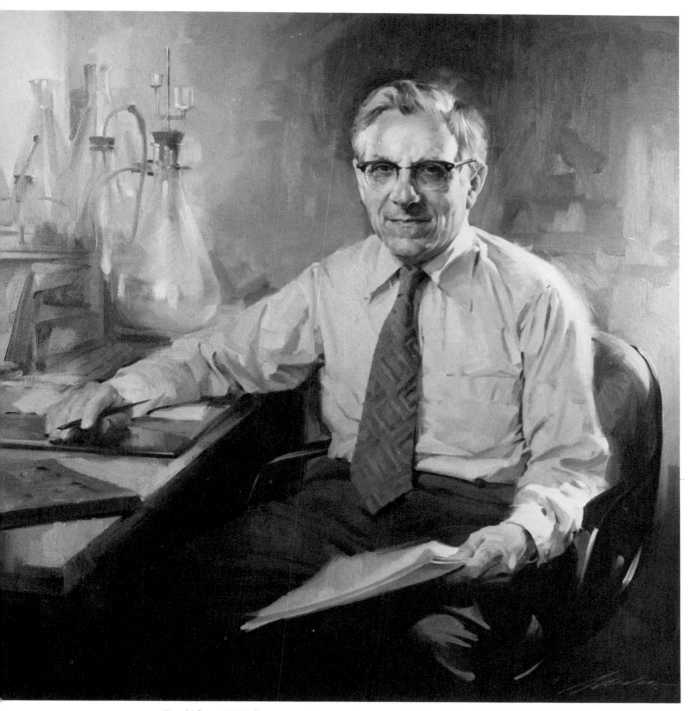

Dr. Sidney Weinhouse. *Oil on canvas, 38" x 36". Dr. Weinhouse is world-famous as a leader in the search for an effective cancer treatment. A terribly busy man, he is one of the most modest and self-effacing people I've ever met. He wanted to pose in his shirt-sleeves, because he worked that way. Mrs. Weinhouse felt that perhaps he should have his jacket on. When I submitted a half-size sketch for the committee's approval, I attached a clear acetate overlay, on which I painted a jacket, so they could view it both ways. When the sketch came back, the overlay was gone, and we finished the painting as you see it here. This is an example of ¾ plus side-lighting. (Collection Temple University School of Medicine)*

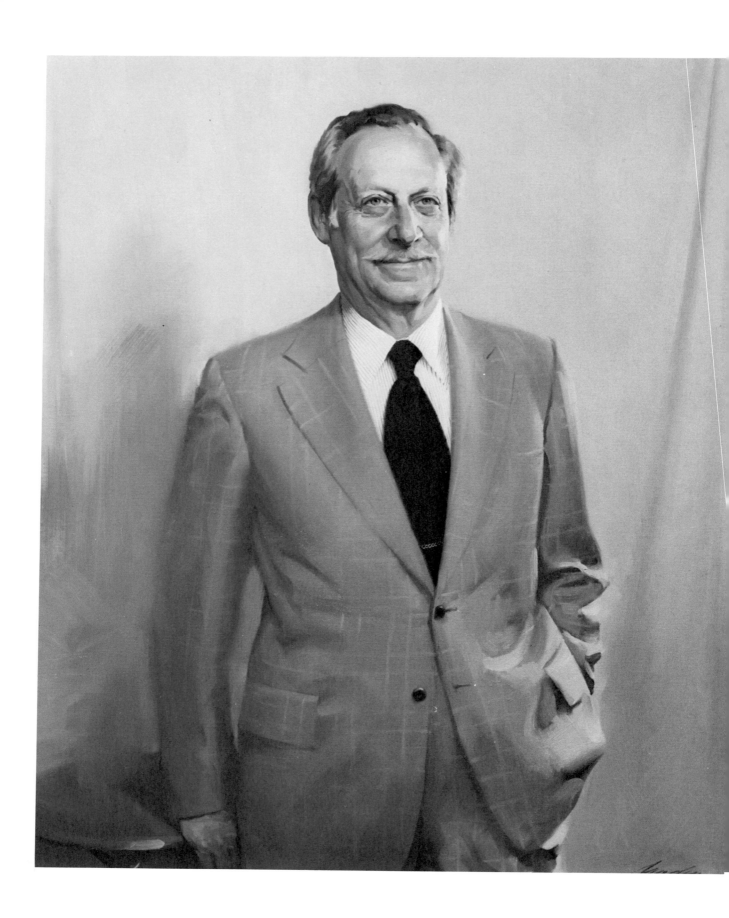

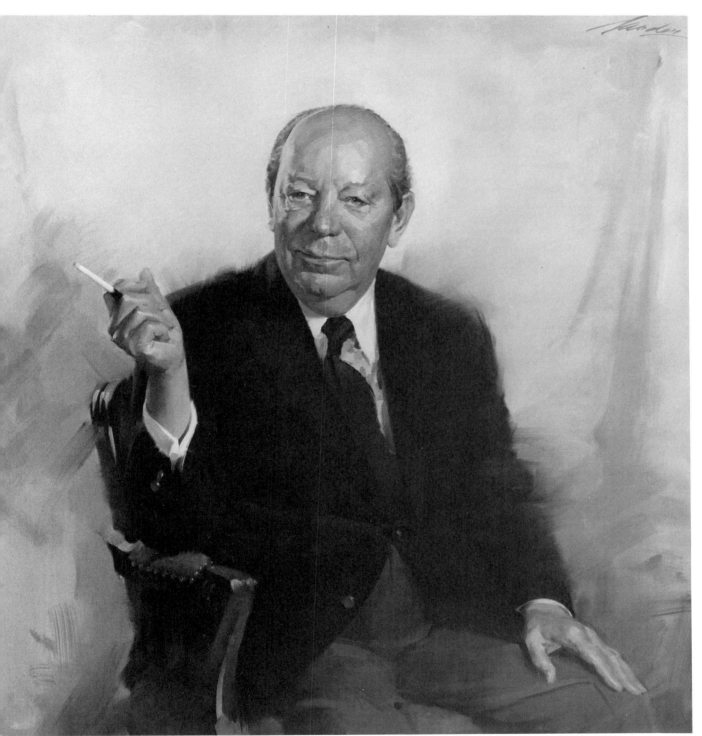

Mr. Jack R. Aron. *(Left) Oil on canvas, 42″ x 34.″ Mr. Aron is tall, handsome, and very distinguished, and I tried to express this through a very simplified composition. Originally we planned to include a ship model on the table to reflect Mr. Aron's interest in nautical lore. But I finally decided, with the Arons' approval, to eliminate the model as an unnecessary intrusion. The pale gray suit and the dull, oyster-colored background made a strong, uncomplicated design. I introduced a side light to emphasize the form. (Collection Tulane Medical Center)*

Mr. Gerald B. Payne. *(Above) Oil on canvas, 36″ x 33.″ Mr. Payne took a natural, informal pose, and the gesture of his hand was perfect. We both wanted a casual, unposed look. The background was almost white and his black jacket and colorful shirt made an interesting composition. (Collection United Gilsonite Laboratories)*

Now decide on *your* viewpoint. You can work with your sitter placed at your eye level or slightly below. Or you might attempt placing him somewhat above your eye level.

None of these poses are *better* than any of the others, they are merely alternates you should consider and finally decide upon while planning the portrait. The one that naturally seems the most attractive is the one you should finally adopt.

LIGHTING THE SUBJECT There have been elaborate textbooks written on the subject of lighting the subject. In the main, these books are best applied in photography where photographers will employ as many as ten lights to illuminate a single head.

For the painter, the traditionally simple lighting plan is best, preferably a single source of natural light illuminating the subject from above. This kind of lighting lends solidity to the form and simplifies the tonal values, forming distinctly distinguishable lights, halftones, and shadows. No elaborate electronic schemes have improved on this simple, basic arrangement.

In planning the portrait, the artist must decide if he will view his sitter from his (the sitter's) shadow side or his light side.

Facing the sitter's shadow side is best for expressing strong character, facing the light side, for achieving a softer, more subtle effect. This latter lighting is therefore best for painting women's portraits.

Occasionally, flat frontal lighting in which the light falls directly from behind the artist produces an interesting effect.

The source of light can also be manipulated to shine up from below instead of down from above.

Here are some possible things to attempt and study: If working from the sitter's shadow side, experiment by shifting the light (or moving the sitter's head) so that a triangle of light falls on the sitter's shadow side, then keep on turning the light (or head) until this triangle vanishes and you're painting with true side lighting. Then again, by shifting the light more to the center, the ear in the shadow will catch the light—which is the exact opposite of the extreme side lighting.

If you're able to adjust the height from which the light is falling, see how this affects the shadow cast by the nose. It's best that this shadow doesn't fall so low as to reach way down to the mouth since this would create a rather unattractive effect.

If your shadows emerge too dense, arrange some source of reflected light to soften them. Photographers claim that reflected lights (they call them fill-ins) should be one third of the intensity of the main light source. You can use either an electric bulb or a white cardboard to reflect the light back into the shadows.

Other considerations guiding your choice of the light bathing the subject are: if it should be warm or cool, strong or subdued, scattered or concentrated.

THE BACKGROUND An important planning decision concerns your choice of the background for the painting. Experiment with backgrounds of various colors and values. These decisions should be based on earlier ones determining the mood and effect you're seeking—strong and dramatic or soft and placid, for example.

The color of the model's hair, complexion, and costume are vital in the

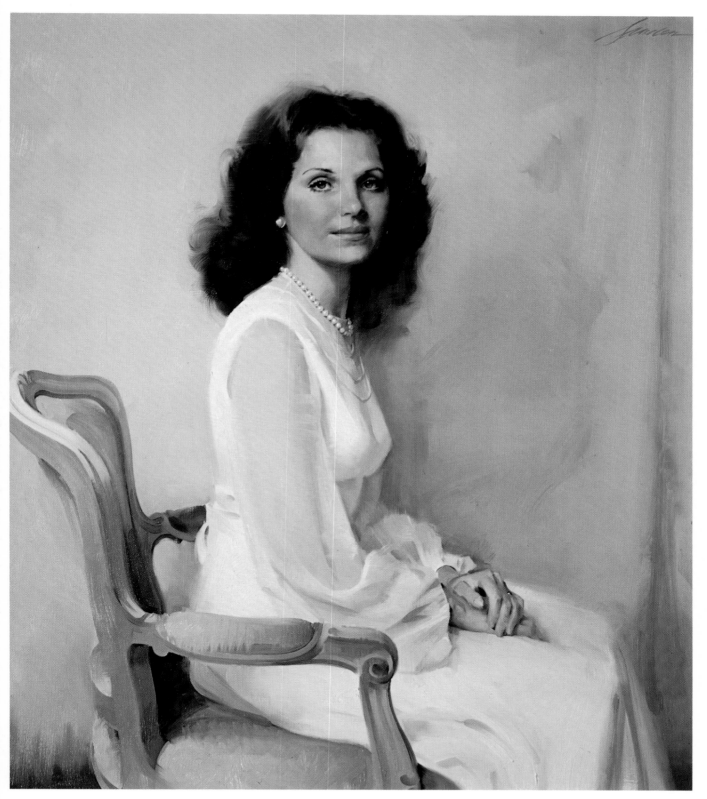

Mrs. Erol Beker. *Oil on canvas, 40″ x 34″. This lovely lady looked like a princess in her elegant gown. The white-on-white composition of this painting was fun to paint, and will fit in well with any room's decoration. (Courtesy Portraits, Inc.)*

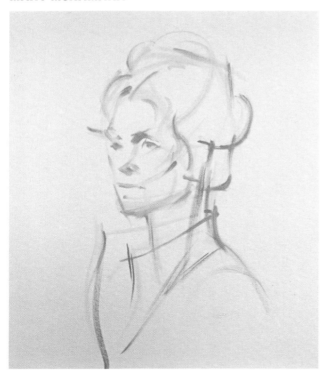

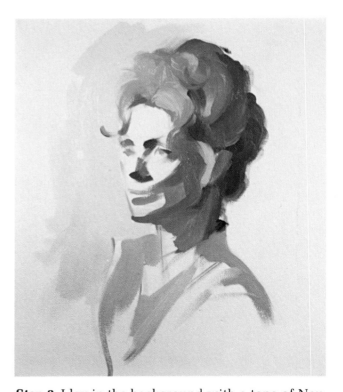

Step 1. Using a filbert bristle brush Number 7 and my premixed Neutral 3, I draw the head in the following sequence: The top of the hair and the bottom of the chin in order to establish the length of the head; a stroke to mark the right contour of the head, then the outer contour of the left cheek; the right and then the left contours of the neck, followed by both shoulderlines. The hairline is next, and a stroke marking the cheekbone. Now I draw in the collar and the shapes of the hair on both sides of the head. I then mark the position of the irises, the bottom of the nose, the upper lip, and the shadow falling below the bottom lip. Next I draw both sides of the jawbone and restate certain passages with darker strokes of color.

Step 2. I lay in the background with a tone of Neutral 3. Then I mix a general tone for the shadow side of the hair—using black, white, yellow ochre, and a touch of viridian to cool the mixture—and cover the appropriate areas with my largest brushes. I mix a batch of color for the lighter side of the hair out of black, white, yellow ochre, and a touch of burnt sienna. After filling in these lighter areas I go back to the previous mixture but with less white this time for the darkest accents in the hair which occur behind the ear, on the back of the head, and in the shadows cast by the front curls. To conclude the treatment of the hair I again use the lighter mixture, but with some additional white for several lighter accents such as the curl next to the ear and the big curl in front. Now I mix a tone for the general shadow areas of the face using my premixed Dark 1 with some chromium oxide green and a touch of white. I brush this tone in over the entire shadow area of the face in a kind of flat, postery wash effect, then place additional strokes in dark areas on the side of the nose, below the lower lip, and in the left eyesocket.

Now I use Dark 2 plus Dark 1 for the darkest accents under the ear, along the right contour of the neck, and on the tip of the chin. Then I go a touch darker still and place several strokes under the nose and in the right eyesocket corner. I also put some darks into the void created by the back of the collar. Now I mix a cool tone of black, white, and yellow ochre for the shadow side of the back of the jacket and a somewhat lighter and warmer tone for the model's left inside lapel.

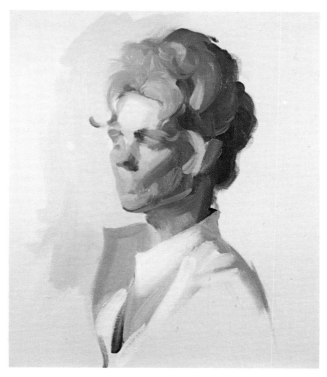 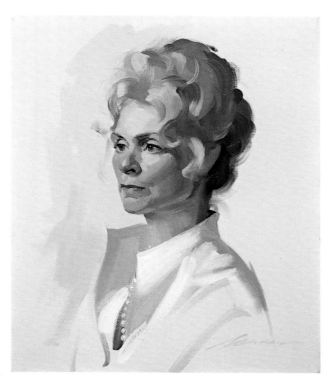

Step 3. Now I paint the halftones, always proceeding from the shadow, right, side to the light, or left side: Halftone 1 and burnt sienna for the mouth "barrel"; Halftone 1, white, and cadmium red for the warmer, lighter left plane of the same area; Halftone 2 plus Light 3 in the right side of the cheek and Halftone 2 plus Light 3 for the left. I then shape the chin, using Halftone 2 and chromium oxide green plus a touch of Light 2 for the right and Halftone 1 with Halftone 2 lightened with white for the left. Now I use Halftone 2, white, alizarin, and ultramarine to cover the eyesockets and Halftone 2, white, and a touch of ultramarine to indicate the center portions of the eyes. I use Halftone 2 and white to paint each side of the forehead. Then I paint the planes joining the cheek and upper lip, using Halftone 2 and Neutral 5 for the right and Halftone 2, white, and Neutral 3 for the left. I paint the nose area in a tone made up of Halftone 2 and Light 3. The plane joining the nose to the cheek is painted next, with a cool combination of Dark 1, white, alizarin, and ultramarine blue. I indicate the reflected light falling into the shadow of the neck with Neutral 3 and alizarin, then paint the front of the neck with Light 1, cadmium orange, and Neutral 3. Now I paint the lights: the light under the eye is Light 1 and Halftone 1; the light under the nose is Halftone 1, Light 3, and white; the light on the tip of the chin is Halftone 2 and Light 3 reduced with Neutral 3; the light on the forehead is Light 1 and Neutral 3. I then paint the halftones and lights on the dress and place the reflected light under the chin.

Step 4. I begin this final step by restating, redrawing, and merging tones and edges. I place the iris color in its proper position, then place some cool grays into the cornea and a touch of pure black for the pupil. Now I paint in the nostril with a single, decisive stroke of burnt umber and alizarin. I model the wing of the nostril and reaffirm the cast shadow. Finally, I put in the all-important highlight—mixed from Light 1 and white—on the nose. I then paint the upper lip with burnt sienna and cadmium red light. I mix a lighter tone, made up of cadmium red light, white, and a touch of Venetian red, for the lower lip. I darken the color with a bit of burnt sienna for the darker portions of this lip then use a mixture of burnt sienna and alizarin to paint in the slash between the lips. I paint in a dark, cool halftone for the area below the lower lip and for the tiny planes on either side of the mouth. A cool halftone is also used to indicate the light vertical plane and the area running into the bottom of the cheek line. I then place a highlight of white and cadmium red on the lower lip. The concluding touches are the catchlights in the eye and an indication of the string of pearls.

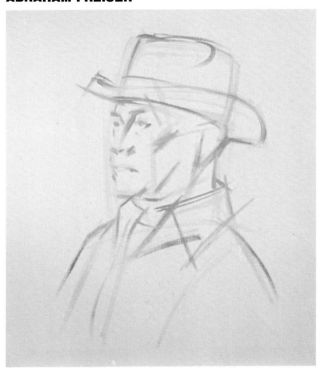

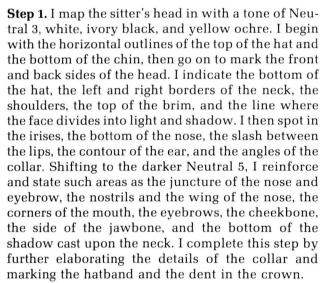

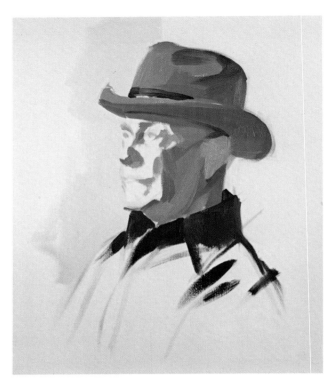

Step 1. I map the sitter's head in with a tone of Neutral 3, white, ivory black, and yellow ochre. I begin with the horizontal outlines of the top of the hat and the bottom of the chin, then go on to mark the front and back sides of the head. I indicate the bottom of the hat, the left and right borders of the neck, the shoulders, the top of the brim, and the line where the face divides into light and shadow. I then spot in the irises, the bottom of the nose, the slash between the lips, the contour of the ear, and the angles of the collar. Shifting to the darker Neutral 5, I reinforce and state such areas as the juncture of the nose and eyebrow, the nostrils and the wing of the nose, the corners of the mouth, the eyebrows, the cheekbone, the side of the jawbone, and the bottom of the shadow cast upon the neck. I complete this step by further elaborating the details of the collar and marking the hatband and the dent in the crown.

Step 2. I brush in a pale gray background made of Neutral 3 and white, with a touch of yellow ochre, then proceed to paint the dark areas of the hat with black, white, yellow ochre, and viridian. A touch of white added to this mixture makes do for the lighter areas of the hat, while a bit of black added to it takes care of the few darker accents. I then mix a general shadow tone for the face, made up of Dark 1, chromium oxide green, and white, and brush it over the whole dark side of the face including the ear. Dark 1 plus burnt sienna makes up the dark area running along the edge of the shadow from cheekbone to chin. For the darkest accents in the face—under the ear and chin—I use Dark 2 and alizarin, and for the reflected areas on the jaw and neck, Dark 1, alizarin, and white. The cool shadow under the hat brim is mixed from Dark 1 and chromium oxide green; the same mixture plus a dash of ultramarine does for the reflected light directly under the chin. I use the general shadow tone to paint in the shadow in the nose, the corner of the eye, and the corner of the mouth. The darkest areas of the shirt are then painted in black, ultramarine, and alizarin, and the lighter parts in black, ultramarine, white, and a touch of viridian. The final step is to paint the black hatband, with touches of gray for the few lighter areas lying within it.

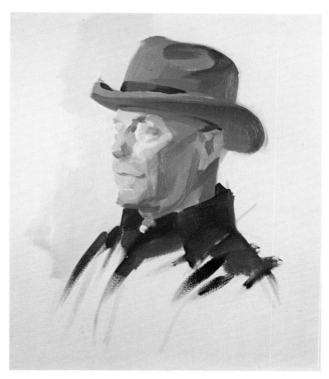

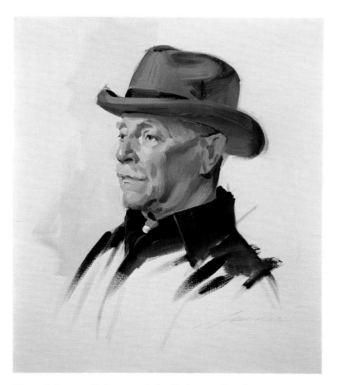

Step 3. I now paint all the halftones in my usual manner, working as always from the shadow side to the corresponding planes on the lighter side. The mouth is first, with Halftone 1 and cadmium red light for the dark side and the same mixture touched with white and Neutral 3 for the light. The cheek plane is done with Halftone 2 lightened with Light 3 and put in with a single stroke. Next, the chin is completely painted in Halftone 2, as is the nose. Halftone 1 plus a touch of chromium oxide green is used for both eyebrows and for the area where the mustache will be. The outside corner of the eye is painted in Halftone 2, Neutral 5, and a touch of ultramarine. The transitional plane separating the shadow and light along the side of the face consists of Dark 1 lightened with some white and Venetian red. The final halftone rounds the bottom of the chin—it combines Halftone 2 and a touch of alizarin crimson. Next come the lights: the one lying between the nose and cheek is Light 2 warmed with Light 3; the cooler light on the forehead is Light 2 with a touch of Neutral 3, and the same mixture is used for the light on the right eyelid.

Step 4. I now fully model all the major forms, restate the halftones and darks, and modify the edges. First I carefully rework the areas under the cheekbones, on the side of the chin, in the eyesocket, and on the tip of the nose. In those places where shadow meets light, I soften the edges all over. I then paint the eye, first placing the dark blue iris, then the darks of the lid folds and the pinks in the appropriate places. Once the position of the eye is established, I shape the nose, beginning with the nostrils where I use burnt umber and alizarin for the openings. Then I shape the wing of the nose, restate the shadows all around, and finish off by placing the highlight with a single stroke of pure Light 1. I then quickly paint the mouth—upper lip first, lower lip second—and finish by placing the shadow beneath the lower lip. I restate the shadows in the mustache and add a few highlights, and I finish the ear by showing some of its major forms with a brushful of burnt sienna.

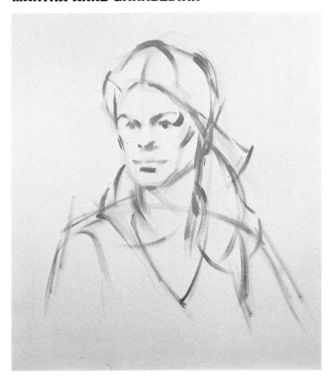 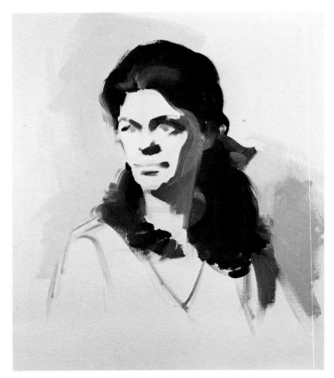

Step 1. In my customary fashion I map the head for the subsequent painting, using a Neutral 3 tone. I begin with the top of the hair and bottom of the chin, mark the right and left outer contours of the head, the jawline, the outer limits of the neck, the curve of the shoulders, the hairline, the line separating the light and shadow areas, the shape of the hair, and the neck and sleevelines. I then turn my attention inward and mark the irises, the bottom of the nose, the mouth, and the shadow beneath the lower lip. Switching to a darker color, I indicate the dark shadow line of the hair, restate the hairline, and mark the temple, cheekbones, and ear.

Step 2. I lay in a tone of background made up of black, white, and a touch of cooling viridian. I then proceed to the hair, for which I mix black and alizarin, and brush over all the hair shadow areas. I use burnt umber, ultramarine, and white to paint the lighter hair areas. Now I mix Dark 1 with chromium oxide green and white to paint in the great mass of shadow in the face and add burnt sienna to sharpen the edge where the shadow meets the light. I darken the original mixture somewhat to paint the shadow cast under the chin and to paint in the corner of the eye, the brow, and the shadow beneath the nose.

I conclude this stage by painting the shadow cast by the hair on the neck and along the shoulder.

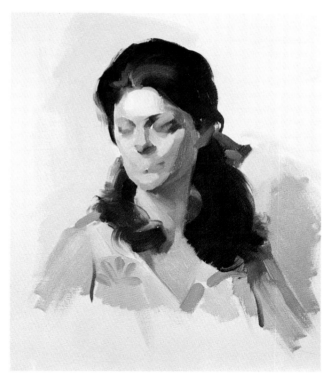

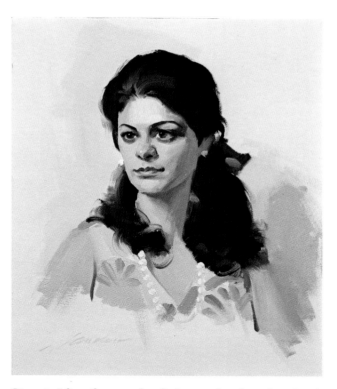

Step 3. Now I paint in all the halftones. First, over the mouth, beginning with the dark side, which is Halftone 1 and Neutral 5, then to the right with Halftone 1 and a touch of Neutral 3. Next comes the right cheekbone, Halftone 2 warmed with a bit of cadmium red light, then the corresponding left plane painted with Halftone 2 and some Light 3. Down to the chin and the halftone falling between the shadow and the light. First, the dark on Martha Anne's right, painted with Halftone 2 cooled with Neutral 5, then the left plane made up of Halftone 2 and Neutral 3. Now the right temple, Halftone 1, yellow ochre, and Neutral 5; the left, Light 2, yellow ochre, and a mere touch of Neutral 5. The side of the nose is painted in a combination of Neutral 5 and viridian and the front of the nose with Halftone 2 and Neutral 3. I then paint over the eyesockets with a grayish green tone mixed from Halftone 2 and Neutral 5 and the planes where the nose flows into the cheek with Light 2 and cerulean on the dark side, and Light 2 and cadmium red light for the warmer left side. The neck and the V of the collar are painted with Light 2 and cerulean, with more blue in the lower areas where the color of the material is reflected. I merely indicate the arms with a Light 2, Halftone 1 mixture, and I roughly paint in the dress color and pattern. Now I turn to the lights: the first is on the cheek, made up of Light 3, cadmium orange, and white; the next is a Light 1 on the forehead; the final is the highlight on the chin mixed from Light 3, a touch of alizarin and white.

Step 4. After the usual refining and redrawing, I rub the eyesocket with my thumb to remove excess paint and put in the dark brown irises. I then paint in the dark areas, shaping the eyes and the brows with Neutral 7. I model the nose and blend the tones to produce the effect of roundness then place several strategic warm accents around the tip. I paint the nostril holes with alizarin and burnt umber and shape the wing of the nose. The final touch on the nose is the highlight. I then paint in the upper lip with Venetian red and burnt sienna, the lower lip with cadmium red and white. I place the dark accents at the corners and into the middle of the mouth. I mix white and alizarin to place the highlight on the lower lip. I put a dark greenish tone under the lower lip. Several cool halftone planes are added at the corners of the lips. At this time I realize that I've painted the chin too long, so I cut it down with strokes of shadow. I finish the portrait by adding the pearls, earrings, and, in a loose, rather playful manner, the pattern in the dress.

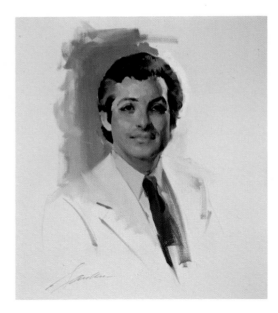

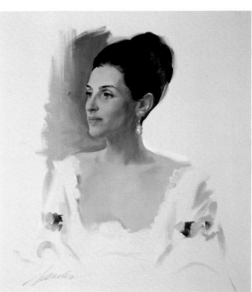

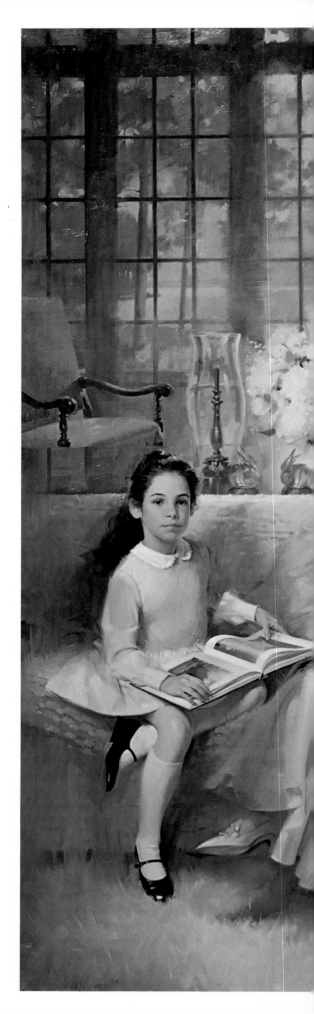

J.D.A. Barr. *(Top) Oil on canvas, 30″ x 24″. In this preliminary study for the family portrait at right, I worked out the problems of Mr. Barr's pose and lighting.*

Clay Barr. *(Above) Oil on canvas, 30″ x 24″. A similar preliminary study of the attractive Mrs. Barr.*

The J.D.A. Barr Family. *(Right) Oil on canvas, 81″ x 85″. This was painted for the Barrs' beautiful Norfolk, Virginia, home. We had fun using Sargent's Wyndham Sisters as a basis for the composition. Mrs. Barr wore a beautiful dress with an intricate brocade. First I made a careful pencil drawing of the brocade pattern, working it out in precise detail. Then I painted the dress completely, without the design, and let it dry. I then traced the brocade pattern onto the painting, by coating the reverse side of my drawing (on tissue paper) with pastel dust. Then I painted the brocade pattern. After it was dry, I washed off (with water) any remaining dust from the drawing. (Collection Mr. and Mrs. J.D.A. Barr)*

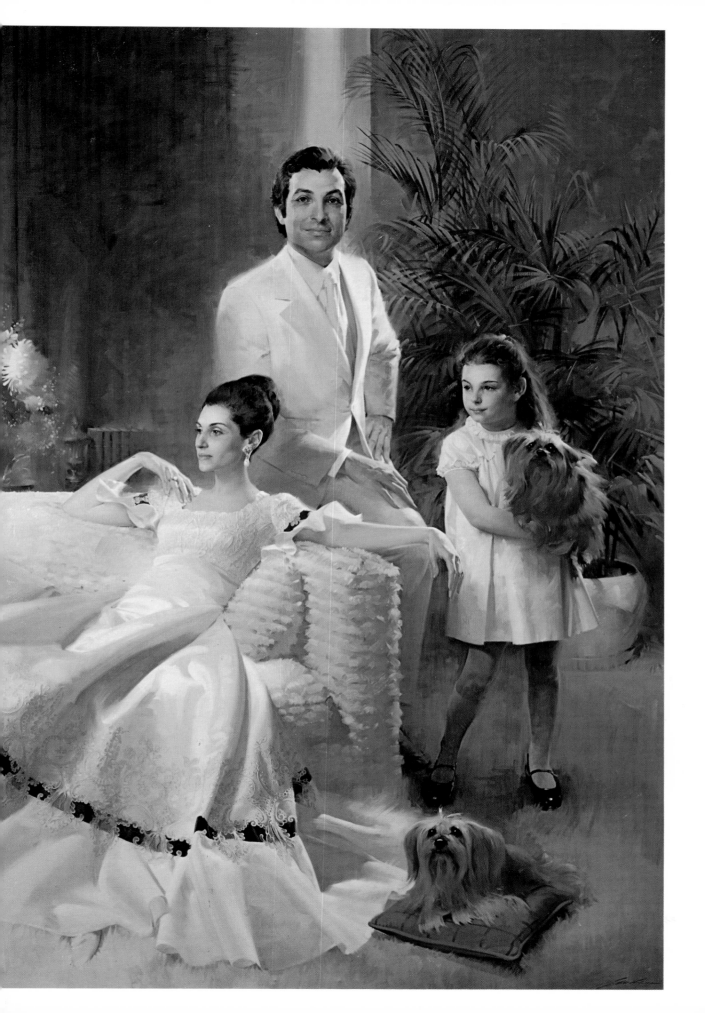

Step 1. With Neutral 3 I mark the top of the head and bottom of the chin, establish the left and right outer contours of the head, neck, neckline, shoulders, lapels, forehead, and indicate the important division of light and dark that separates the head. I then mark the irises, nose, mouth, lip shadow, tie, and hair.

Step 2. A background of light gray is put in, then I move on to the hair. I paint the darks with black, white, viridian, and yellow ochre, adding more white for the lighter portions. The big dark areas of the face come next. The overall shadow tone is Dark 1, chromium oxide green, and white. For the darker accents along the shadow edge, I add more green and for the lighter reflected tones, more white and a touch of cadmium red. The ear is painted with a bit more cadmium red, and ultramarine is added to the overall mixture to show the cool light reflecting from the shirt under the chin. The entire cool shadow on the temple is painted in white, ultramarine, and alizarin. The shadow side of the shirt collar and jacket, the shadow cast by the tie and lapel, and the shadows in the eyesockets, the corners of the eye, and under the nose are placed next. The mouth and shadow under the chin come last.

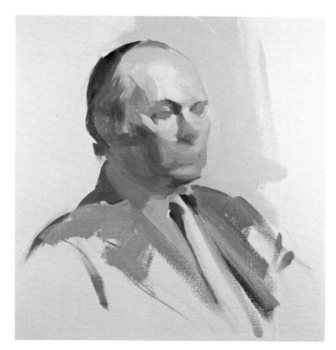 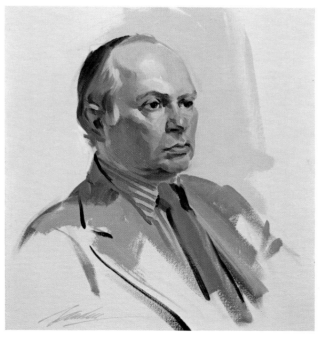

Step 3. I begin by painting over the mouth area, starting as usual from the model's stronger shadow area. This is done with Halftone 1 and Neutral 5. The lighter plane on the other side is made up of Halftone 1 and Neutral 3. The plane next to the left cheekbone is a mixture of Halftone 2 and Light 3, and the lighter plane on the right is Light 3 plus a touch of Halftone 2. The chin is painted in Halftone 2 and Venetian red. The left forehead plane follows, in Halftone 1 plus alizarin and white; the lighter side is Light 2, Halftone 1, and a touch of yellow ochre. Halftone 2 and cadmium red are used for the nose. The eyesockets are done with Neutral 5, Venetian red, and ultramarine. The forehead tone just above the light area is pure Halftone 2. On to the lights: the one on the cheekbone is Light 2 with a warming touch of cadmium red light; the forehead is Light 2 and yellow ochre. Several appropriate lights are also placed in the shirt and jacket.

Step 4. I now finish the head by attending to the features, starting with the eyes. I first place the dark brown irises then paint the darks that form the eyes and the eyebrows. Next I model the nose, placing the nostrils, shaping the wing and tip, and finally inserting the highlights to bring it forward and lend the effect of roundness. Next I paint the mouth, beginning with the upper lip and moving on to the lower lip, the slash between them, the darks at the corners, and finally the highlight on the lower lip. The shadow is placed beneath the lower lip and further modeling is done on the area between the nose and the upper lip. I then model the ear with dark strokes of burnt sienna and umber and follow up with highlights of alizarin and white. I add cool reflected lights, which pick up the colors of the shirt, and finish by painting in the tie and the pattern of the shirt.

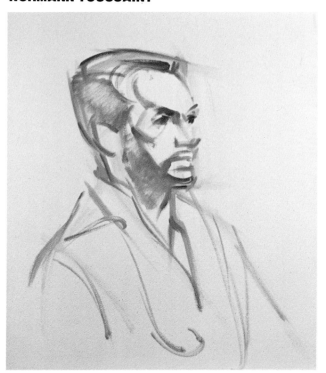

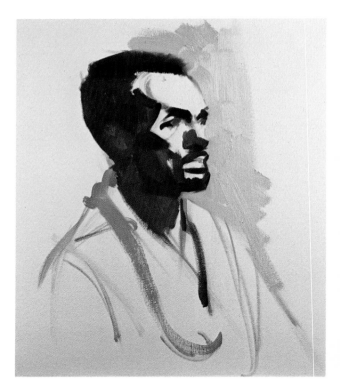

Step 1. With a Neutral 3 tone, I mark the top of the head, the bottom of the chin, the left and right perimeters of the head, the neck and shoulders, and the line lying between the shadow and light. Next, I indicate the hairline, eyes, nose, mouth, collar, lapel, shape of the hair, and placement of the ear. The final strokes mark the beard and mustache.

Step 2. I brush in a background tone of black, white, and yellow ochre, then paint in the darks of the hair and beard with black, burnt umber, and alizarin, with the addition of white for the lighter areas. I then mix a general tone of shadow for the face and neck from Dark 2 and viridian and add some burnt sienna for the shadow of the nose. The eyes are painted over with the same mixture used for the overall shadow. I also indicate some shadows in the clothing.

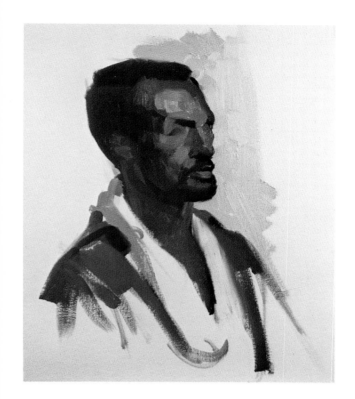

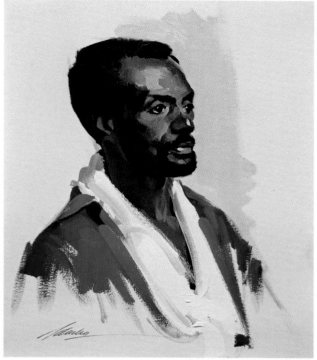

Step 3. I paint all the halftones, beginning with the mouth area, which is a combination of Dark 2, viridian, and white. Next comes the cheekbone, made up of Dark 2 and burnt sienna for the darker side and Dark 2 and Venetian red for the warmer, lighter side. The right temple is put in with Dark 1 and cadmium orange and the rest of the forehead except for the lights, with Dark 1, chromium oxide green, and a touch of black. The nose is painted with Dark 2 and burnt sienna and the neck with a pure Dark 1. The bridge and frontal plane of the nose are done in Dark 1 and cadmium red light. The upper lip is Dark 1 and chromium oxide green and the dark area below the lower lip consists of Dark 1 plus a dash of ultramarine for a really rich, dark accent. Now I turn my attention to the lights: in the forehead the color is mixed from Halftone 2, chromium oxide green, and a touch of white; the light under the eye is Dark 1, chromium oxide green, white, and some cadmium red light; the light area just off the wing of the nostril is a mixture of Halftone 2 and Neutral 5. I then brush the highlight onto the forehead, using a blend of burnt umber, ultramarine, and white. The shirt is indicated with alizarin, burnt umber, and black. Additional work is done on the lips. The upper is burnt umber, alizarin, ultramarine, and white, the lower, Dark 1 with cadmium red light.

Step 4. Now I mix burnt umber and black for the irises, pure black for the lashes, black and burnt umber for the eyebrows, and alizarin and white for the reddish areas of the lids. I place the all-important highlight, which in this instance is composed of ultramarine and white, on the nose. The highlight on the lip is alizarin and white, and the one on the chin is mixed from chromium oxide green, white, and a bit of burnt umber. A number of reflected lights appear on both sides of the neck. The one on the sitter's right is mixed from chromium oxide green, black, burnt sienna, and white; the one on his lighter left side, from Dark 1, ultramarine, and a touch of white. Finally, some lights are placed in the ear, pure white is thickly brushed into the shirt, and several strokes of cadmium red light are used to indicate the sweatshirt.

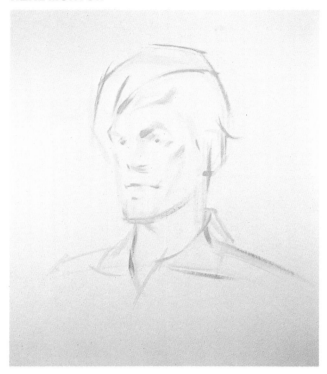

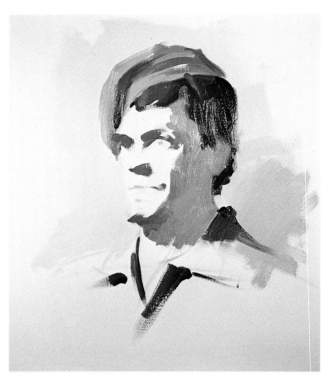

Step 1. I start by indicating the top of the cap and the bottom of the chin to establish the length of the head, and go on to mark the left and right edges of the head, neck, and shoulders. I indicate the shape of the cap and its bottom, the hairline, and the division of light and dark on Neal's face. Next comes the jawline and the ear, followed by an indication of the eyes, nose, mouth, and collar.

Step 2. The first step is to lay in the background of white, black, and yellow ochre. Next comes the cap—the darks first, in chromium oxide green, viridian, and burnt umber, then the lighter portions in cerulean, viridian, and cadmium yellow light. I follow this by painting in the shadows in the hair, made up of burnt umber and alizarin, and go on to paint the lighter hair areas with burnt umber, burnt sienna, and white. Now I mix a general shadow tone for the face, which is Dark 1, chromium oxide green, and white. The reflected light falling into this dark area is painted by adding Venetian red and white to the overall shadow mixture. The darkest shadows in the eyesockets, below the nose, and under the chin consist of this general shadow tone with a touch of burnt umber added to lower the value of the mixture. The final step here is to use ultramarine, black, and white for the shadows in the shirt.

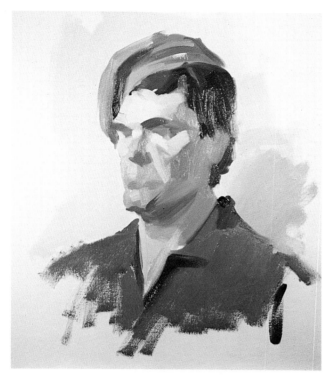

Step 3. I now follow the same pattern as I do each time I paint the head—all the halftones first, all the lights next. I start with the mouth area, made up of Halftone 1 and Neutral 5. The darker right cheekbone plane is painted with Halftone 2 and cadmium red light; the lighter left plane, with the same mixture plus some white. The right chin is next with Halftone 2, and the left with Halftone 2 and a touch of Neutral 5. I move to the right temple, which I paint with Halftone 2, chromium oxide green, and white. The corresponding left side is Light 3 with a touch of Neutral 5. I paint the side of Neal's nose with Halftone 2 and chromium oxide green and its front with Halftone 2 and Venetian red. Halftone 2 and viridian are used to completely cover the eyesockets and Light 3 plus cadmium red light for the neck and the V of the shirtfront. The upper lip calls for a mixture of Halftone 2, chromium oxide green, and Neutral 3; the plane beneath the lower lip, for Halftone 2 and viridian.

Now for the lights: Light 3 and white takes care of the forehead and the bridge of the nose; under the left eye I place a light mixed from Light 2, alizarin, ultramarine, and white; the darker light plane under the right eye takes a mixture of Light 2 and Neutral 5. Light 3, alizarin, and Neutral 5 are used to produce the light tone in the chin. Finally, I use ultramarine, white, and a touch of umber for the lights in the shirt.

Step 4. In the final stage of the painting I refine the shapes and colors of the cap with mixtures of chromium oxide green, viridian, cadmium yellow light, cerulean, and Venetian red. I restate and reshape the hair and all the shadows in the head, particularly where light meets the shadow, in order to establish the strong character of the sitter's features. I warm and intensify some of the halftones throughout and reshape the left outer contour of the face to some degree. I now build up the dark shadows of the eyesockets and mix and place the irises, which are a combination of chromium oxide green and burnt sienna. The lashes are painted with burnt umber. I reshape the nose and put in the nostrils and wing, then deepen the halftones in and around the mouth and paint in the upper lip with burnt umber and burnt sienna and the lower with Venetian red and white. Umber is added for the darker accents at the corners of the mouth, the dark area under the lip, and the darks in the ear. At this time I decide that there is too much shirt showing and I brush gesso onto the canvas and lose much of the material into the background.

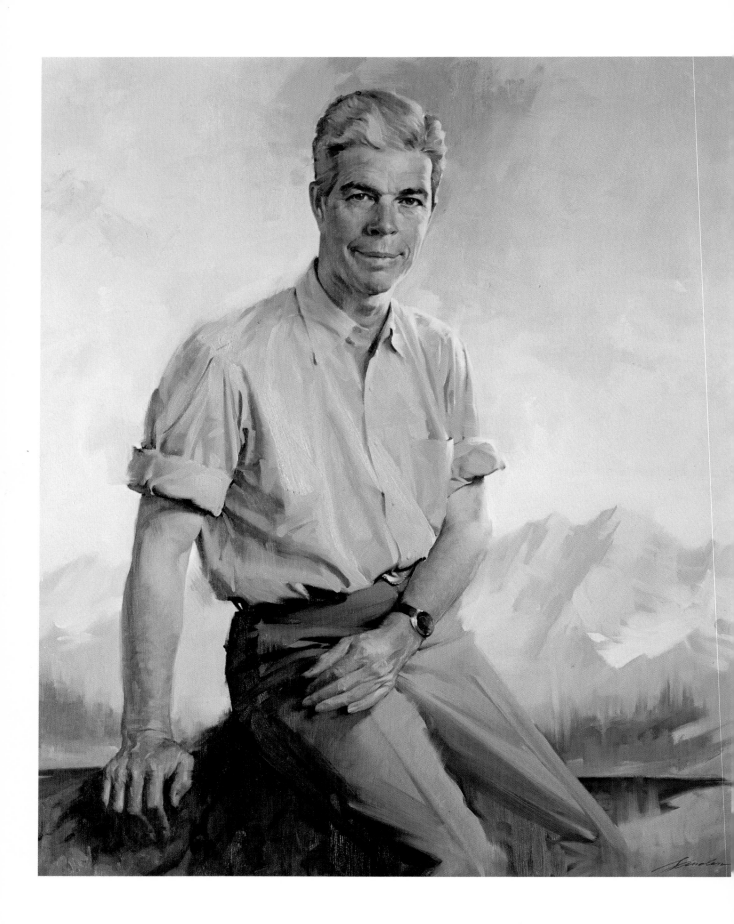

determination of the background. A few general guidelines to follow are:

For blond or white hair use a darker, contrasting background.

For brunet hair use a middletone background running more toward the light side if it's contrast you're seeking.

For a punchy, dramatic effect employ a background of value and color the direct opposite of the subject's.

For a soft, subtle effect use a background that's close in value and color to that of the subject.

In my experience, I've found the ideal background to be one that is a single value darker than the darkest halftones in the sitter's face.

THE FINAL CONSIDERATION

Having diligently evaluated and planned the size, the spirit, the dress, the pose, the lighting and tonal arrangement of the subject, it pays to take a final long and calculating look at your sitter before pushing ahead.

Before the very first stroke can be laid, there are at least a hundred decisions to be made, and the responsible painter must learn to juggle the swarm of thoughts racing through his brain and to translate them into an effective working procedure.

Quietly stand and consider your subject. Try to reduce him to these basic elements: the background; the hair; the light side of the face; the dark side of the face; the costume.

Note the values. See how the lights relate to one another and then do the same for the darks. Check the contrasts of value. Try to fit all the tones in the face into the value range scale graded from 1 to 9.

Study the proportions. How does the head relate to the background, to the shoulders, to the neckline? How do these elements relate to one another? Note the large areas of the subject. What elements constitute each one?

At this stage, don't think about the sitter's personality. There's ample time for that when you're painting the features. Right now you're only concerned with shapes, colors, and values. At this time it's the masses, the abstract shapes that matter.

For the moment, disregard detail. Leave that for last.

Look, weigh, and evaluate the big forms, the simple effects of light, the fundamental shapes, the basic tones and colors.

Now you're ready to proceed painting the head.

Senator Peter H. Dominick. *(Left) Oil on canvas, 40" x 33". The handsome Senator from Colorado posed for me in his office in the Old Senate Office Building in Washington, D.C., sitting on the edge of his desk. The shirt he had brought from home turned out to have a huge tear in the sleeve but we went ahead anyway and I repaired the shirt with paint. We worked each evening after Senator Dominick had spent a full day on the Senate floor. His right hand was constantly in motion as he took telephone call after telephone call. Hard work for the painter, but the Senator remained gracious and charming throughout. (Collection Senator and Mrs. Peter H. Dominick)*

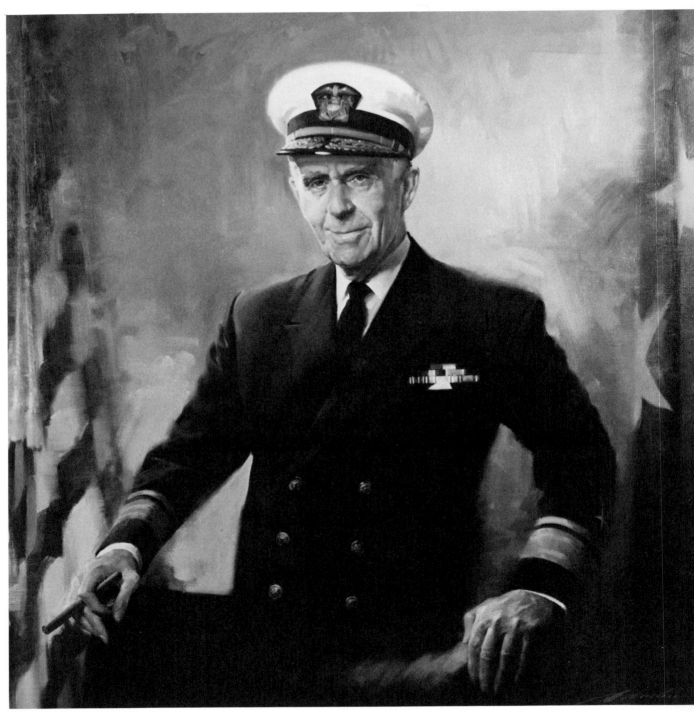

Rear Admiral John J. Bergen. *(Above) Oil on canvas, 42" x 40." Admiral Bergen is a strong, magnetic man. He posed for me in his office at Madison Square Garden in New York, where he is Honorary Chariman of the Board. There are three departures from Navy regulation in this painting: the cigar, the pocket handkerchief, and the jaunty angle of the hat, but I suggested that we show it to Navy men for their reaction. Everyone who saw it insisted that the hat angle, the cigar and handkerchief were Bergen trademarks and had to stay in. (Courtesy the Navy League of the United States)*

Mr. Charles Baskerville. *(Right) Oil on canvas, 50" x 45" (Detail). Charles Baskerville is one of the best-known of all American portraitists. He sat for me in his elegant New York studio and it was a daunting experience to paint him among his own great paintings and trophies. But he genially cooperated and made many helpful criticisms and suggestions as I worked.*

ACKNOWLEDGMENTS

I would like to express my appreciation

. . .to Don Holden, who urged me to write this book, and who perservered with encouragement, wise advice, and kindliness in great amounts.

. . . to Joe Singer, a fine artist, a tireless, impeccable craftsman at the art of writing, and a gracious gentleman. We have become fast friends during the writing of this book.

. . .to Andrea Ericson of Portaits, Incorporated, for her all-important guidance and assistance.

. . .to Susan Meyer for first suggesting the possibilities of this book.

. . .to Stewart Klonis and Rosina Florio of the Art Students League for their confidence and support.

. . .to my wife, Elizabeth, for providing the atmosphere in which all this could be accomplished, and for her untiring help and counsel. Without her, nothing would have happened.

Bibliography

Blake, Wendon. *Creative Color: A Practical Guide for Oil Painters.* New York: Watson-Guptill, and London: Pitman Publishing, 1972.

Charteris, Evan. *John Sargent.* New York: Charles Scribner's Sons, 1927.

Doerner, Max. *The Materials of the Artist: And Their Use in Painting with Notes on the Techniques of the Old Masters.* New York: Harcourt Brace Jovanovich, 1949.

Henri, Robert. *Art Spirit.* New York: J.B. Lippincott, 1930.

Hogarth, Burne. *Drawing the Human Head.* New York: Watson-Guptill, 1967.

Mann, Harrington. *The Technique of Portrait Painting.* Philadelphia: J.B. Lippincott.

Mayer, Ralph. *The Artist's Handbook of Materials and Techniques.* New York: Viking Press, 1970.

Ormond, Richard. *John Singer Sargent: Paintings, Drawings, Watercolors.* New York and Evanston: Harper and Row, 1970.

Singer, Joe. *How to Paint Portraits In Pastel.* New York: Watson-Gupill, and London: Pitman Publishing, 1972.

Index

Edited by Margit Malmstrom
Designed by Jim Craig and Bob Fillie